SEEKING AIR

Books by Barbara Guest

The Location of Things (Tibor de Nagy, 1960)
Poems: The Location of Things; Archaics;
The Open Skies (Doubleday & Company, 1962)
The Blue Stairs (Corinth Books, 1968)
Moscow Mansions (Viking, 1973)
The Countess from Minneapolis (Burning Deck, 1976)
Seeking Air (fiction) (Black Sparrow, 1978;
Sun & Moon Press, 1997)
The Türler Losses (Montréal: Mansfield Book Mart, 1979)
Biography (Burning Deck, 1980)
Quilts (Vehicle Edition, 1981)
Herself Defined: The Poet H.D. and Her World (biography)
(Doubleday & Company, 1984)
Fair Realism (Sun & Moon Press, 1989)
Defensive Rapture (Sun & Moon Press, 1993)
Selected Poems (Sun & Moon Press, 1995)
Quill, Solitary APPARITION (The Post-Apollo Press, 1996)

COLLABORATIONS WITH ARTISTS
Musicality (Kelsey Street Press), with June Felter
I Ching (Mourlot Publishers), with Sheila Isham
The Altos (Hank Hine Press), with Richard Tuttle
The Nude (International Editions), with Warren Brandt
Stripped Tales (Kelsey Street Press), with Anne Dunn

BARBARA GUEST

Seeking Air

SUN &
MOON

CLASSICS

103

LOS ANGELES
SUN & MOON PRESS
1997

Sun & Moon Press
A Program of The Contemporary Arts Educational Project, Inc.
a nonprofit corporation
6026 Wilshire Boulevard, Los Angeles, California 90036

First Sun & Moon Press edition 1997
10 9 8 7 6 5 4 3 2 1

©1978, 1997 by Barbara Guest
This book was previously published by
Black Sparrow Press in 1978.
Reprinted by permission of the author.
Biographical material ©1997 by Sun & Moon Press
All rights reserved

This book was made possible, in part, through contributions to
The Contemporary Arts Educational Project, Inc., a nonprofit corporation.

Cover: Barbara Guest
Design: Katie Messborn
Cover Typography: Guy Bennett

LIBRARY OF CONGRESS CATALOGING IN PUBLICATION DATA
Guest, Barbara [1920]
Seeking Air
p. cm — (Sun & Moon Classics: 103)
ISBN: 1-557713-260-7
I. Title. II. Series.
811'.54—dc20

Printed in the United States of America on acid-free paper.

Without limiting the rights under copyright reserved here,
no part of this publication may be reproduced, stored in or introduced into
a retrieval system, or transmitted, in any form or by any means
(electronic, mechanical, photocopying, recording or otherwise),
without the prior written permission of both the copyright owner
and the above publisher of the book.

Preface

In real life I have only a dusty view of time. Seeking Air is a record of time. The time is the 1970s. I composed *Seeking Air* in the same apartment in the E. 90s looking over the East River, as *Moscow Mansions* and *The Türler Losses.*

It was an oddly arranged apartment with its small bedroom overlooking the East River. In *Moscow Mansions* it appears in the poem about the Chinese courtesan. The East River, the kitchen, everything, except Moscow, itself, is in that apartment to be redolent with memories also of *The Türler Losses,* whose real home is the Hamptons.

Seeking Air is a book of the 1970s, despite its having gained purpose and momentum from my reading the Diaries and Letters of Jonathan Swift. The apartment its hero lives in is the apartment I have above described, somewhat enlarged to contain Miriam on her indecisive visits. She sleeps, as I did, on the Chinese courtesan's bed that appears in *Moscow Mansions.*

The East River has as much importance in *Seeking Air* as it does in all the words I wrote in that apartment. The outside balcony which is shadowy in those other works now becomes an important part of the geography of *Seeking Air.* It was narrow, far too narrow for *Dark's* pacing, a strip of cement that rolled around the corner of the apartment house with a railing for safety. If managed carefully there was room on it for two chairs. When I had a visitor,

or when I wanted a change of air I used to sit on the balcony. It was really an unimprisoned piece of space I could use to collect my ideas about the novel and spy upon the world outside that was bringing its debris to *Seeking Air*.

This book is also a record of life on the eastern end of Long Island in the 1970s. It is a little late for the invention of Abstract-Expressionism which took place earlier in New York City, and continued unseasonably out there in the town of Springs. What was unique about "the Hamptons," and kept it free of the limitations of an "art colony," was that there had been for generations people who spent summers and also winter weekends out there.

Our hero's parents have a house and we visit it. The Hamptons had the kind of beauty city people could tolerate. Although, commuting and its difficulties was a matter of discussion between Morgan and Miriam even in the '70s, the need to "commute" reflects the New Yorker's uneasiness in the country and restlessness in the city.

I began *Seeking Air* in Water Mill, L.I. in an unheated house converted from stables. Foolishly (and romantically) I rented it in winter. The pipes burst in the cold, so that for the remainder of my residency the rooms smelt of horses. But the house gave me the scene at the shower with Morgan. (I did not then know *The Türler Losses* were also to be written and completed in another house in Water Mill.)

I borrowed Miriam's name from her appearance as the heroine in the novels of Dorothy Richardson. The novels, although separately titled, also appear under a leading title, *Pilgrimmage*. They begin (1905) when in England women are learning to ride bicycles, to vote, to type, to enter

offices. It is these earlier books which interest me. Miriam's progress is identified with the advent of Modern Woman.

Richardson, while continuing to promote political and above all, social freedom for women, was also developing a method in her novels known as "stream of consciousness." She may or may not have been aware of a similar experimentation by James Joyce. She is a woman's heroine, of course.

My Miriam is fearless, pointedly more so than her lover, Morgan. I believe her actions show she is often frustrated, because so much of her life is dependent on his moods. He maintains their "structure" with his pursuit of his ideas, his dedication to "Dark," the subject of his undisclosed manuscript, and arrangements for their personal life. Selfish Morgan, in a Swiftian way, obsessed with himself. Writing in the 1990s I would be more stern toward him, perhaps, more relentless on the subject of the fascination of women for difficult men. But then the *tone* of the book might slide, the lightness I depend on, shrink.

My model as I instruct my readers, from the very beginning, was that difficult genius, Jonathan Swift, who left us an extraordinary Diary of his relationship with a woman whom he educated, cultivated, and with all his genius for "little times," exploited.

—BARBARA GUEST

to Mary Abbott

It ought to be an exact chronicle of twelve years from the time of spilling the coffee to drinking of coffee. From Dunstable to Dublin with every single passage since . . . two hundred chapters of madness, the chapter of long walks, the Berkshire surprise, fifty chapters of little times.

Dean Swift to Vanessa

Begin with telling her everything, she had said.

This provoked me into wanting to say less and less.

Yet there was such a marvelous, such an extraordinary circumference around what I might or might not tell. I thought about it. I never thought about it less than an ordinary day. I considered it into the reaches of the night. Even past novel reading or picture seeing. I wondered what it was that I might say to her. These are all parentheses, thoughts also, they go, as one would say, along the routes. They march down the avenues.

There is no point in telling you about the Ecuador or Chinese shops. You have heard about them. You have even visited the squares and sat in front of the flags. You have even entered the buildings. I think you have been just in your remarks. Not always swimming on a bland bright day with the sun at your heels, not always acquiescing to the psalm singing drift of the white lilted bright Asiatic day at your roots. Do you think so?

And now that we are quite away from everyday, now that we have forgotten perhaps to say now and wander correctly groomed, I wonder. Are you like a movie? It began this way.

I am Laffide.

She is Laffida.

We have no nationalities, no borders. We have no wars. We are a couple. One of us likes to travel. One of us fears movement and prefers to stay at home. One of us likes men. One of us likes women; we are objectives. In some way we must make a living. This can be done by changing the verb or noun object. One can also change a record, or perhaps give up a car forgetting the numerals.

I think of myself in a certain age group. And I have been reminiscing. I have been putting myself in the place of—well whoever it is—someone not here. I have been dreaming of a sentimental bookshelf. But you have never read the book that begins with Dark and never in your dearest moments thought you could capture the sequence of that Dark which is what someone once asked of me. Could this be done? Of course I said no. We are living in another generation. We are living.

> *Do you think it will be as if we were unable to find the boat going from shore to shore? I do. I do, indeed. You are the unrecognizable*

shore and that with the drift of weed about it. It only takes a tunny ship. The big birds go there and we are afraid of them. Someone has defined ship as shore. A quick, lunatic man. I think the gulls know best. One can even describe persons. Why do they draw in sand?

Why have I sat in a square room in a city describing a plan. Which rooms did I get wrong? How do you spell tobaggan? And words like operetta. Someone said if you think like La Belle Helène, but I don't. Then it would be another problem. Twinkletoes. I don't believe you think of Fred Astaire, because you never told me so. It well may be. It well may be like the slow lights of a town. The train is going to the city. The workers will go tomorrow to the city. Yet now they are enclosed in their houses. Even they have little stories told about them.

They have visitors to their town. Criminally assaulting the city with their plans, and their hopes. Yet always witholding like underbrush the rabbit. I don't know. I keep saying I don't know. That is because I am awaiting your answer. Your answer will tell me what I am awaiting. You who are such a foreign person. I don't mean foreign to our shores, yet never have you experienced the dubious joys of sailing forth into this wilderness. Or I don't think you have. Perhaps you have? Perhaps you are a refugee? Perhaps your name is in reality such a foreign cognomen you will explain all this to me.

With you I may place a foot upon the lost way.

SEEKING AIR

1

I began to know you somewhat when you introduced me to your friends. That is, I began to see you outside myself. I was permitted to witness those aspects of your person which were not private. The public view, as a painting seen at an exhibition, is so important. You know how often I have repeated that a painting varies in values when seen in the studio, at a gallery, or in a museum. How often I have been enchanted with the work of a painter when it was showed at the studio, brushes in hand, the cup of cold coffee on the table and here and there the evidence of a struggle in the crumpled sketch paper or the postcard tacked on the wall or the notebook open to the three scrawled lines, written no doubt in the early morning. And the variation at the exhibition of this same painting, its statement lost among the personalities.

And didn't we enjoy that museum in Siena? Despite your cold and runny nose, the missing tissue. Especially keen to us was the landscape outside the window corresponding so exactly to the painting on the wall. We were quite unable to "judge" the value of the paintings themselves. They might have been rather ordinary, as indeed, I remember many of them to have been. Here for an agreeable time was no element of art "triumphing" or "improving" nature. Nature and art were in such similitude due to the exact degree of their presentation; due that is to the light reaching into the room, to the color of the ground and to the distance of the hills, each of which appeared in the painting.

And so it was with you, Miriam, when you said in that voice which is so like the color of your hair: "This is Robert. This is Celestine."

Robert I did not like immediately. I resented his having known of your existence longer than I. Then he is handsome and I am not. An old-fashioned attitude of mine. It seems no longer one makes the choice of deciding if a person is handsome. Like so many disappearing conveniences which have been replaced by

other conveniences, the æsthetic of the human face has been withdrawn. Now one says, "He has an interesting face" or more likely, "He looks like his sister," or again, "How virile," or again, "I like a nose slightly out of joint." Note that one never mentions, as ethics also are changing, "a corrupt mouth."

Do you suppose people still say, "He wears his heart on his sleeve"? I know very well that a few romantic exchanges still persist. Just the other day someone said to me, "How Doris has changed. Her eyes are so dark and sunken. She has cried too much." And it was true. The life of Doris was beginning to disintegrate, or rather she was in the middle of that era in her life when a decision needed to be made which she sought to postpone through constant tears, tears that successfully hid what she could not bear to see. I know also that Annette was chastised because her face was becoming too "full."

Actually the plumpness of her cheek line gave it a mature beauty. But it was not the æsthetics of her face which were questioned. No one, I reiterate, cares much about the proportions of beauty. What exactly was meant was the moral comment that Annette had been drinking too much and this incontinence was betrayed by her face. Nearly always our comments are relative to the presence of the superlative. One can permit the comparative, indeed that is what success is based on, but the superlative is disastrous.

There is something a little superlative about Celestine. Can I guess it is because she loves Robert too much? I noticed she was unable to concentrate on our conversation. I wasn't altogether flattered that it seemed a matter of indifference to her whether or not she was introduced to me. Celestine likes you. But I don't think she approves of you. She is given (part of her superlativeness) to conclusions. From a few "chance" remarks, such as, "Miriam you should go out more," I gather she has concluded you live too much the life of a spinster. How ridiculous this is we both know. Celestine really does admire an intense love. You can tell this by the way she dresses. There are so many open spaces in her clothing and then they are flattened out. In order to vary her ensembles she adds a bit too much. It is like her apartment where we went afterwards. I like it when she uses primary colors, but she does not understand dark corners. There is too much eloquence in

her window dressing. You see how given one is to criticism of a superlative sort of person? I hope I didn't show my distaste for the way she made our supper.

It wasn't the food, it was the preparation. Those "let's have" and "put in another can" and "one should always use" I objected to. Robert was pleased with the meal and she appeared to enjoy our conversation which might have been about the sunrise for all I know. It was only when he began to tell us of his trip to Asia that I woke up. I was reminded of a trip I had made on the Nile which reminded me of my mother's earrings which reminded me of the garbage which used to collect under her window in our summer house which reminded me of my sister Jennifer's bicycle I used to borrow on a glowing morning which reminded me of you who have always reminded me of Jennifer.

And so I began to relax in the company of your friends, because they were part of you. I knew that after a few hours I should see you alone and then I would see you differently, then you would be part of me, but I did want to postpone your separation from your friends so that I might study you more octagonally; you were still only rectangular to me and I wished to seize the opportunities of our supper party. Now you are more like a pebble. Your sides do not match; you are neither round nor square, yet you are beginning to have a promising shape.

I almost came upon it in the dark. When we were alone at my apartment. You were lying on the sofa and your head fell slightly to the left. Your skin was a dark green. Your eyelids were that natural grey and your hands slightly yellowed, a spot of moisture above your lip. You were speaking of revolutions and the shortening of the span between medieval and modern. Your laughter occasionally broke into black lines, the spaces contravening between thought and speech. Your long upper thigh was stretched tensely toward an object I could not see, but which I understood to be just out of my reach. It was the posture of the lion in the cage whose paw gropes outside the bars for a lump of raw meat. I snapped open the lock and opened the cage. I hoped to discover under that mild manner of yours the ferocity which I had noticed when you bit into a piece of cake that evening in St. Augustine.

Miriam. You have been given the perfect name. There are two vowels and three consonants.

2

The next morning after you had left I was neatening your traces. You do leave behind you an extraordinary disorder. That was what I thought when first I knew you. Now I recognize your assortments. There is a lucidity in your placing of personal objects. On one table the hair pins. On another the powder. Here is a half-eaten pear. In the bathroom the soap has slipped to the floor. A lipstick lies on an ash tray in the middle of the bed. And yet there is "order, clarity, lucidity." And there is a purity in your design, like a Matisse painting of "Studio." It took me a long time to learn this.

At first I was scandalized, as was my mother with my adolescent room. I can see her stooping over a garment, questioning me why I live so differently from her and father. Following her eye to the lawn I would think of the linen closet with those elegant shapes of towels and sheets and wonder, indeed, why my own closet, my bed which I thought of as my splendid tent, should be so messy. Later when I owned my own apartment I became obsessively neat. I missed my mother.

I wanted to tell you about my return to my parents' house. It was last summer when you had gone off on what you call your "assignments." I know they are not assignations, but this business life of yours is so disparate to me; your life in what is known as "outside our world" is so cloudy to me that I cannot fictionalize Miriam meeting a strange person, Miriam asking this person an intimate question, Miriam writing down what is said in her notebook. You have showed me this notebook. To me it is only filled with diagrams of train schedules which explain to me where you will be in one hour when I shall need you.

3

Last summer I went to the country to look at our old house. My parents had always been so unfortunate in business dealings that it had become impossible for them to find a tenant for the house. Going over my objections they still could not find someone to buy the house.

I seldom visit this house, but it was a dry summer, a hot summer. I knew that the house by the sea with its furniture shrouded in sheets would be cool, even chilly. When I opened its windows the sea air would blow through it, pushing out the smell of mothballs and old mattresses. The tap water after the first rush of rusty water would be clear, cold, cold. I could walk to the ocean and bathe each day, returning to that old outside shower under which I used to stand letting the sand and salt water wash off me, the shower water running into the slightly browned grass around the drain. I used to think of myself as a gazelle at a watering spot! Later, many brave animals who had come to the water hole briefly to drink.

In those days I was always changing myself into an animal. When I was a unicorn it was in the parlor near the watercolor picture of Mélisande. I remember that she was looking sadly into a pool where her gold ring had been dropped. I was angry with her because she had betrayed me with King Pélleas. I had confused my centuries; any lady in court dress would hold the head of a unicorn in her lap. For Mélisande the unicorn could only be a myth about which she had read, who had once appeared in another country. You know that I remedied that error in my book which is now translated into several languages.

4

There is a dog who lives near our property. There is always a dog, but this spaniel I could see watching me from across the lawn. As I went from room to room opening the windows I would see him racing back and forth in front of his house. At night when I would climb the stairs, crossing the landing, going from room to room turning on the lights, I would hear him howl. Finally the watchful presence of this animal to whom I had made no overtures, but who so concerned himself with the movements of my life, began to disturb me. I decided that inasmuch as he was the only species of life in that community who was aware of my identity, that is, the peculiarities of my personal habits, I might very well make overtures toward him. Keep in mind I had been staying in the house, talking to no one, going each day to the sea for a swim, and returning to a shrouded house to cook my meal, to reminisce, and go to bed. I was aware that after I had retired he would come to my house, poke into the garbage, roam about the grounds and sniff at the porch. Yet never in the day time.

One morning after my swim, when I was showering and recalling my lost animal identities, I saw him sitting halfway up on the lawn. I whistled. How long it had been since I had whistled! It was such a dusty noise, yet he heard it. There he was bounding toward me. To shorten this, Miriam, we became friends. Whereas formerly my tracks had been from the sea to the house, now he began to accompany me about the grounds. He knew those old paths better than I. He took me to the barn, then to the carriage house. It was there I made my discovery the consequence of which has set me on an entirely new train of metaphysical enquiry. The results of which can only be antithetical to those of my colleagues. Yet what are colleagues? Enemies!

The grass was rougher, tougher in certain clods. These clods stood out against the clean, thin, fresh slips of grass. They were coarse-grained and the clods were in the shape of a horse's hoof.

These were the same tracks that had been made by my grand-father's carriage horses. They were the tracks the horses had made when we children rode over the lawn to the fury of our elders. What a cautious hoarder is nature; how sly and penurious, how reproductive, how unforgetful. She likes to hear the same old opera over and over. Nothing new about her. Reflect that I was led to these conclusions, only a fraction of which I have stated here, by a dog.

I shall not bore you any longer with these reminders. Long Island is not Balbec, any more than Balbec is Combray. Any more than I would use a bathing machine.

5

Dinner at my apartment. An evening with a New Zealander.

I received a telephone call from young Tom Powell saying he was passing through this city. He was bringing a herd of cattle to New Zealand from Ireland! Tom is the brother of Sheila, a delightful girl who was the governess of the children of friends with whom I had stayed in London. "Gouvernante" was really the term the hotel people liked to bestow upon her, the hotel where she and the child would have dinner. Actually she came from that indispensable British agency, Universal Aunts. Sheila had accompanied a family of Americans when they travelled to France, Italy and Greece. The good humor and manners of this girl (23) were compelling. If she indulged herself in moods this indulgence certainly took place privately. She was fond of her young wards. She was pleased with the countries she visited. (Liking Italy less, a bit overwhelmed by France, an admirer of Greek ruins.) Her geographical and presumably cultural education completed she wished to return to New Zealand. We had been surprised at her decision, thinking she might marry a Welshman, a farmer, who had grown up near the border, quite near the spot her family had emigrated from. However, such is the pull of her island that Sheila desired to return to it.

I have photographs of her wedding which took place at Waipawa. There stands the wedding party in front of the white wooden church. They are properly arrayed in taffetas and borrowed formal dress. On the wedding group shines that white clean New Zealand light, the envier of shadows. It is an English wedding. An Episcopal style church. Bless Sheila, she will have children named Diana, Rosemary and Guy.

Arrival of Miriam. Her first New Zealander. She helps with the table. She is in a friendly humor. Arrival of Tom.

He is tall, well formed, blond and healthy-cheeked. His hair is

cut in a bang across his forehead. This once might have signalled the country bumpkin, now it is a modulated version of the current long hair. Fresh from a British barber. Its original cut modified somewhat by his recent stay in Ireland. A ruffling of the locks into authenticity.

Tom delights us. He is simple, direct (as was Sheila), he appears to have none of the traces of inferiority toward more cosmopolitan places as would his contemporary from this country. We were both rather overcome by this person. Later in the evening a wee bit bored.

His most important remark, or so I thought, aside from his description of loading the cattle onto an airplane in Ireland, was made when he told us of visiting Westminster Abbey on Commonwealth Day. The remark was: "You know we used to sing those old Episcopal hymns in our little church. I never quite understood what they meant, although I would sing along. Then we sang the hymns, the same ones in the Abbey. A great throng there was and a large choir. Suddenly I understood about England's fair and green land. I knew about the Lord being a Shepherd, because I had tended sheep, but I hadn't before realized the sheep in the hymns were thousands of people, not just wooly bleating animals."

I think Miriam liked best his telling us of visiting the minister in Shropshire. Miriam was teary-eyed when Tom told us the minister was the last of his branch of the Powells, and further was preaching the last Powellized sermon. Would Tom return to hear another sermon so that another Powell would sit in the congregation? That he wouldn't.

I forgot to say Tom brought flowers. Red and white carnations for Christmas.

A well-articulated man who carried himself well. Large flushed hands.

19

6

At the movies with Miriam. Another Italian import. I fell to thinking about a review I had read of a book called *The Case for Spelling Reform*. The question was: is there a case for spelling reform? Henry Sweet, "the greatest of all English philologists," thought so. The book was written by Mont Follick. This kept me occupied through three quarters of the film. I then cast a few shadows toward the Shavian alphabet. I finished the last episode of the movie with a Shavian denouement in mind. Follick believed that the adjective "subtile" was derived from "the days when the Roman philosophers used to wander up and down under the lime trees trying to emulate each other with clever arguments and phrases, often splitting hairs over very fine differences, so *subtilis* was born—lime tree being *tilia* in Latin."

7

Things have fallen out and things have
fallen in.

Miriam we are going to Minna's. Ah this is when you put your
hand in mine. We are going to pass through the corridors of—my
past. Then stairs. First up to the rooms. We push the bell.
Someone nearby says, "They wouldn't let me into the bar of the
Seven Seas." We are in a hallway. Miriam. I touch you. You who
have never known the years of these rooms. I feel your heavy
dress. We go up the stairs. There it is.

This is the water's music. I am walking by the water. I am
telling you my sister, you are syllables. You are the music dropped
on leaves. I am saying there is the funeral of Lenin. If you wish to
listen. I am saying we are living at the top of the house and there
the chords make such a sound the steeple sweeps sideways against
the sky. And then we begin.

8

It is six A.M. in Los Angeles. The hour of first light. A beginning of a day which has no changes, remaining all seasons, a boy with his wheel.

Ah Miriam, we are lying together on such a low bed. Not at all like our old bed. It is really a pallet. The light from the ceiling hurts my eyelids and I think of morning's cool haze. So dark at first then a faint light, then the roses strewn; yet hesitant, somehow careful, as if the roses were floating into day which carried a handful of cards, a bright deck hidden in the palm.

Searching you. The light on your face. The yellow.

Miriam, where are we?

Your skin. Dowsed with light.

Except that Miriam we are in New York and you have promised that there will be no deaths. Before I tell you a few extraordinary tales.

It is night. I have told you about the jewel robbery about the man "who didn't care" and about the bedrooms filled with watches. You have told me how you froze in your black winter coat (like Roman cherries that coat). Even if the fur did rough up the edges and make you fear that "snow will never settle here."

Morgan!

I am listening. My real dreams hurt you. Stabs of joy.

9

It's laudanum time.

A wisp of green sunset falls across the chaise.

The papa of Elizabeth is pacing his study floor.

The dog thumps his tail.

The book of poems quietly turns its leaves.

Robert rounds the corner, his boots chumping in the watery snow.

The heavy eyelids of Elizabeth stoop lower into the smile at the mouth's bend which is slightly plumper with patience.

The Jamaica bananas with their soft round toes.

I like astrakan sunsets on the rug. And "gaudy melon flowers." And the firm bite of exile.

Robert has arrived. He has brought a present. It is called *The Care of Books in a Tropical Climate*.

It is the last Christmas on Wimpole Street. They are going to the land of Ruddigore.

Miriam exits with a flick of the fingernail. Ta.

10

I have changed to the new typewriter with the large type. Sadly, tenderly I put the old one in the closet. And I confess only to you, Miriam, how near I was to tears. The letters I have written to you on the old typewriter. The hours I have spent in front of it seeking your image, or trying to reclaim your image from the alphabet that settled over your face. The sentence that would describe with its careful punctuation (and its momentous pauses while I lit a cigarette) my exact feeling for you and the tonal area of our solutions.

Now space enlarges in front of me. The proportions are attenuated. There is more prose on the roller. I must maintain my former techniques at the same time as I move stealthily into the new structure whose windows are still dark.

I am only beginning to "touch" it. And I have been seven years "touching" your face.

11

And I returned to "Dark's" exegesis. Which if ever finished I shall deliver No. 3 in the series of "Evenings Of and About Literature." Transforming the wild evenings of Alaska into something less raw, translating the kayak noise into black clefs, white floes into Dark. Don't tremble Miriam when I put the bandage over your eyes; we shall only slide into the underground. And we can read standing up the gold emblems of Dark. A nest of swallows clinging to the sooty bridge. Dusk into Dark. Night imagery or scenery, symmetry of night thought. From a broad vision, like balsam on the ah—hair.

12

Now this is Stella's case in fact,
An Angel's face a little crack'd.
(Could poets or could painters fix
How Angels look at thirty-six:)

................................

And let me warn you to believe
A truth, for which your soul should grieve:
That should you live to see the day
When Stella's locks must be all grey,
When age must print a furrowed trace
On every feature of her face;
Though you and all your senseless tribe,
Could art, or time, or nature bribe
To make you look like beauty's queen
And hold for ever at fifteen;
No bloom of youth can ever blind
The cracks and wrinkles of your mind;
All men of sense will pass your door,
And crowd to Stella's at fourscore.

SWIFT

13

Miriam betrayed! That was a ridiculous conversation at lunch. Time must be taken captive. Simultaneity, contemporaneous, consecutive. Onomatopoeia. My answer. Time must be taken captive. It can no longer play its artistic tricks on us. The flow of the moving line does not stop at the knee. If the burden of following your skirt at its hidden length, if your face followed by your hair moving in concentric lines, if your mouth juxtafixed by your nose and your jaw with its arc leading up to the browward curve, your body spaced in flowing air must be contained in idiom, made minor by fashion and framed so that any walking critic can comprehend its grace then ars est breve. Alors! Hein! Let us get to the skin of it, or the bone where the Chinese hide out. Close to the marrow.

14

Surfaces. I set the glass down on the table. The table beside your bed. For now you are ill. After that lunch in which time was lessened, shortened, adulterated. You said take me home. I am tired. And then lying back upon the bed, your head squat against the pillows, the mythic hand upon the counterpane, face fallen in, a bluish line at the corner of your nose—the lines of your neck accented—a poise of defeat—low sails. Why?

It's simply that he wishes to be *au courrant*. He thinks that's the way one is.

In fashion!

It is a shadow, dear girl, and I stroked her hand.

But there's something so evil in a desire to cut life into patterns . . . eras. To limit life to an exact moment when one appears exactly on time—. This never happens. We only show ourselves in snatches, and then, no one knows the date. Where is all if—

Severely I answer, customs have their limitations.

So do mice.

I bring her marmalade in a jar and the rest of the cheering tray.

15

Miriam is worried. She was going along in her usual way, reading papers, etc. Looking at a magazine which always had concerned "other" people, shop windows dressed for "other" people. Now what has happened (although she does not understand this) is that she has been forced to view herself as one of those "other" people. Someone has recognized her. She has been told, and more frequently of late, that she is mortal. She has been struck down in flight, a victim of vogues. *En vogue.* If you aren't there now you'd better be. Hasten.

Actually so much am I involved with Miriam in every aspect, so much do I sense and partake of her spirit (too much so, for often I permit her carelessly to do my "feeling" for me) that I am least aware of anyone of her connection in time. What is she wearing? I see her in a color, or feel the fabric of her dress. Thus when she is wearing wool I am warmed and my hand becomes more muscular as I move over the humps and haddocks of the cloth. Or when she wears a silkish fabric my temperature adjusts to it; I can almost guess accurately with my eyes closed the color of her dress. I was not able to warn her that one day she might finding herself "dated," feel threatened and the need to affect a change. For me her permanency in the scheme of things was fixed. It was she who was the "genius of the place."

It is true she had changed from the time when I first met her. It took me years to learn how to construct the sentences which would be useful to relate our story to ourselves. When finally it came in parts, the vision and the metaphysics themselves began to untangle, thus preparing me. My apprenticeship had been served and I was thus able to inhabit her.

The subtleties of structure could then be put to use. Of course I was only mid-way, yet I never thought of time. Time was so fluid, because I was approaching a goal which stretched endlessly before me. I was nearer this goal, or object, only as the stations were met

and crossed, only as the tunnels or mountains appeared and the track continued on the other side of the mountain. As one tree was examined in a forest of many species. And so if any change could be said to have taken place in Miriam it was through my series of photographs. She was a constant on the plain I was searching and as with all constants, she varied according to the difficulties or ease with which I might film her on my varying landscape. And the scale might alter; it might be diminished or it might be enlarged according to my sights. Thus she was a true mistress.

To continue. I also shared her distress this day, because suddenly she had been evicted from my "here" into the "where" of others. Also adjusted according to their time-scale. It was a thievery and I was shocked. But this I must never let her know. Now my problem was to discover or invent another form for her that would give her at least an imitation of our former world. And it might not be an imitation. Perhaps formerly I had been too complacent. Perhaps now another instance was demanded of me. A risk. My "exegeses" I saw must be put to other uses. I was rather in the position of a man who had carelessly assumed his bank account was balanced and was now informed that his bank account had ceased, had for a long time held no funds and he had not known this because he no longer wrote checks on it, had been living on a private sum hidden in a drawer. This sum, although diminished, did still exist, but certainly could not continue to support him indefinitely.

And so I wrote "surfaces." I must bring these physical structures to life in order to bring relief. I could not relinquish my symbols. Yet I must activate my world with a real world which appears on surfaces. I must begin to describe whole objects, not the partial, indicated, oblique objects of my previous exegeses.

Sitting that day by Miriam's bed, the late afternoon light circling the lamplight, I knew I must extend my experience of her, so that she might breathe ceaselessly. I was making dangerous abbreviations, yet I could only go to myself for solutions. Fortunately I was so devoted to Miriam that I had no idea at the time of the abyss over which I was going to throw my plank, or abysses and planks and ladders and ropes, all the paraphernalia of risk which I should need. My new typewriter.

16

I began asking myself what it is that prevents us from becoming ghosts.

Our Zodiac. I heard myself saying this aloud. Being under the sign of *un temperament nerveux*, subject to stomach disorders, I immediately began to suffer stomach pains. Of course they might have been hastened by the cucumber sandwich I had been eating and the glass of beer on my table. Washing up the manly last night's cup and saucer, ruminating in the kitchen as the pigeons cooed against the window sill and the snow listed against the glass, I was tempted by some cucumbers. Their green shell like a promise of spring, their chorus of seeds and the modesty of the pale fibre I find irresistible. Especially in winter in an apartment when I play at greasy Joan while Shakespearian rags tune up my ears. Then the medieval foam to toss it off.

Zodiac! Destroy these mortal pangs. Advance my planet of "the great spiritual sign." My moon tumbling in the Twins' arms. Demeter, goddess, who guides my earthbound trek warm me with your hands that plant the tubers, the bulbs, your hands on which the earth had made its sign. You are my practical nurse I trust you are watching over me while I lie under the mosquito net of my fantasies. These fabrications.

And indeed you do restrain me. How else would I manage my efforts at efficiency if it were not for you, Demeter? The need for clarity and order in this absolute mess of things. Demeter with her strong paw sorting it out. Leaving one a little stupid in the process, like a potato.

In their helpful hints toward a vocation the astrologers say I might become a technician. A dietician. An accountant. Perhaps these "fields" exactly define my real labors. These exegeses are arrived at through highly, ah, from low to high in one morning and back again in the evening at low to find a high which prevents sleep—developed techniques? And what—if not a diet—is this feed I give myself in my explorations of Dark? I am fairly

experienced here, tossing myself a crumb, watering it, digesting it with a twinge or two when I haven't followed the prescription, beautifully if the tract is in order. When I have been good to myself, letting the sufficient air surround, no indulgence in obnoxious liquids. Arriving healthily at the exposition of Dark. Dietetics certainly require heroism, a herbaceous fondness for the food that nourishes. Courage after swallowing the bitter seed not to throw it up. The ability not to chew the fat of others, those colleagues who having gnawed the bone throw it to you. The bone you had buried. Well there are a lot of old pieces of meat around and some raw ones too. A dietician knows how to recognize in this raw the one to freeze.

Someone once said to me, Morgan, you have never understood that actions lead to results. (Unlike the rest of us!) That's not altogether true, but there's enough certainty in it for me to add that I frequently don't know what I am doing. If I did I should never be so concerned with Dark, which up until now has been my life's work. Or the work of my lives. That is the debit side of my Accountancy. Yet I have heard wise men say, "There's no accounting for it." Still others, "It doesn't add."

There was one who was able to compute the number of troops at Thermopylæ by adding the amounts of grain and wine sent to the ships. Well I too have my days in the harbor counting the amphora.

The painter, Ingres, born under my sign. How often I have stood looking at "The Viscountess d'Haussonville." She is at the Frick Museum near my apartment. When first I saw the painting I did not know about our sign. I saw the picture from a distance, from another room where I was admiring a Velasquez, the figure in it reminding me of a California friend of Spanish descent. It was his identical face. I became absorbed in my recollections of those years in California when I lived in the green cottage in the glen and this friend on the mountain slope. I could hear the rain rushing down the glen and see the muddy road where the drains formed pools where a famous writer used to sit "fishing." I could smell the damp walls and the kitchen with its pot of lentil soup on the stove. Very European I was told. "Like Paris at the Villa," said the writer. I could hear the rustle of that writer's notebooks and the water drawn from the tap for his watercolors on days when he was

too fatigued or too nostalgic to write. And high among the trees in his cabin leaned the Velasquez face with its long jaw and blue eyes. The face as narrow as the glen, fatally elegant above the cast-off clothing of his shabby life with its generous offers to share his empty days.

These recollections made breathing difficult. My hands were loosened from their wrists. I even began whispering to myself as in a slow stumble I went toward the door of the next gallery. There I saw her Ingres blue dress.

Immediately I was seized by that painting in such a strong way that I chided myself. How inconstant I was, and how clever, to shake off the grip of that Velasquez pain so quickly. Like the novelist who finds for his hero another chapter in which to solve his misadventures.

Her sober eyes beckoned. I walked toward her, no longer stumbling, in a long stride, again like a novelist's hero crossing a ballroom. It was towards the folds of a nineteenth century dress that I hurried. This plump woman with her discarded fan and her accoutrements of jewels and flowers leaning against the pure mantle of the stuffy room called to me in such a way as no one in real life had ever done before. From that moment I was in love with her. She listened to me, her bent elbow gesturing every so often as she agreed with my feeble and ecstatic compliments. Her eyes in which just the slightest stupidity was elevated by an intensity which I interpreted to be a longing to go with me out of that room. To walk with me in the park across the street and discuss with me in slow, heavy sentences the fate which had brought us together.

Or rather the "philosophy" controlling our meeting—for the Swiss are fond of this subject. Also there would be the "morality" of our being seen together. So much more! Those pale reflecting eyes suggested that only I could share her passions. Our nineteenth century love duet! The *femme propre* and the emotional scholar walking each day from his rooms to address his awkward compliments.

This is what being born under my sign had led me to. Ingres had taken much the better way out by painting her. Knowing exactly where to fault the proportions, allowing her to become only his subject, a showpiece of his technique. What a brilliant

performance, one says of this painting by Ingres. Not, "I wonder who she was?" But I know. She was the daughter of Mme. de Stael and Benjamin Constant. Perhaps this genealogy explains the final seriousness of her. She was serious. And in her way sensible enough to recommend that I look elsewhere on earth for another woman. That I not go on sorrowing after her like Werther, because in her set Werther was a little laughable.

17

In my history, before Miriam, one event led to another. This was the accountant side of my horoscope. Obviously, since the spell of Madame d'Haussonville had not ceased, I was only going to become interested in a woman who in one aspect or another resembled her. There are many pale, plump, blue-eyed ash-blonde women in this city. I followed one into the subway.

Although younger than the lady of my portrait, she was wearing a coat, tightly buttoned, and to me intriguing. I was determined as I sat next to her on the subway to find out if there were a blue dress underneath it.

Carefully I put the evening paper in front of me so that my eyes might be shielded. Mainly I wanted her to cross her legs so that the coat might fall open. She sat rigidly still. I leaned toward her, pretending, as they always do, that it was the motion of the train causing my movement. Nothing. Moving my eyes upward from her legs I saw that her hands were clasped in front of her. From the stretched skin of the hands I learned that she was tense, the knuckles were clearly defined—despite their exciting plumpness. I dropped my paper and in picking it up my arm touched her legs. I accentuated this, making my movement stronger. The coat slipped, but not enough. Roughly I brought my paper up against her thigh. The coat opened at the last button. She was wearing a blue dress! With one hand I brought my paper up in front of me with the other I hid my eyes. Despair. And yet perhaps. I lifted my hands and looked sideways at her. With pale, blue, intense eyes she was staring at me. *Monsieur*, I mean, *je m'excuse*. Ah! I don't speak English very well.

You don't speak English! My darling! In your exquisite Swiss accent you have begged my pardon in French! It began there and continued over coffee and then dinners in the apartment of the governess for such she was, and ended one evening after a party at the Swiss Consul's. My extraordinary luck in having found this

creature who fulfilled all the demands, ran out only when I realized that my obsession had prevented me from not having discovered sooner that above the pale orb of blue not one little tremor of sensitivity had ever passed.

18

I am really ashamed of the previous passages. Because in relating them I have used the mannerisms of a foreign correspondent or a third embassy secretary, or at least what I think are their *gestes*. Probably they resemble me rather than the other way around. My excuse is that I have been doing some part-time work for X. So impressionable am I that as he dictates his memoirs his style has an immediate effect on me. The original of this episode in which I in no way took part occurred on a train between Vienna and Prague.

19

Dark's London day. I was looking out the window across the lawn to Wren's building. Pensioners bright. Children in grey. The Soane addition. Gothic barracks. Brick, grass, classic stone and people wandering into landscape and architecture. River near. Cruel, historic voices. Or so my rhythm says bouncing off the window on to King's Road. The fine spume of rose at three o'clock. Sun slashed by fog. Turner's hour. September going into October and November. The eccentric light display. Tea in the country. The horse in the drawing room and Lord Berners in mufti painting the horse while the girl holds the reins. And tea in the country. Railway stations panting for tea. Chocolate, tea, Bovril? Italian paintings at the British Museum. Dulwich. Where the light passes white over our throats and no ochre darkens until it's five o'clock. The tumbrils of September.

And the trouble with you Morgan, is you've never settled down. I've watched you. When things become a bit difficult, or the hour chancy and warnings of panic, you move. There's always a house to leave, a person, a train to catch, you've arranged it. This spoken in deep snow. Roads icy. Why don't you remain with . . . sunset into dusk. After September the roads have changed.

20

With Miriam in Washington. Green air of Washington spring. A memory of Dumbarton blossoms—an acre of daffodils held to their stems by that Chinese poem.

I am . . . my heart is too filled with death to sleep in Washington.

Hanging my foot over the bed in the heat, searching the cool midnight air. Falling. Put a strand of your hair in my mouth, Miriam, a trellis.

Tony Smith's sculpture. *Smoke*. Not Turgenev. Irish legend, empty castle. If you turn your back on it the sculpture disappears, as a faery on waking. An Irish Corcoran to be emptied by Dark of Tony.

Heat . . . sleep . . . hiding . . . away . . .

The new buildings. Sullivan without ferns. Dear one, you are now anointed on crumbling Connecticut Avenue in a renovated building serviced by newly indentured Mahli.

Searching the Congressional Library for Dark.

Stop. It's raining. We must pay our respects to the Greek grocery and buy a little sandwich.

Then through the mausoleum of the Union dead to our train. The fatigue of Dark heavy as rhododendrons on my shoulders. Potomac shadows where it is always Halloween.

21

Collyrium. Collyrium. Washing the grit of Washington. Standing in the cold brook washing with delphic water; my satyr hoof stuck in the mud and Miriam holding the towel. Such is our homecoming. Pebbles of dried tears fall in the basin where the fish nuzzle them.

There in the study. The lamp on the table between us. Each stroking the smooth curve of the lamp. She with her right hand and I with my left. We are enduring another return from my biography.

Why do you keep me here beside you?

Falsely, I answer: So that you can go nowhere else.

Sparrows in the machine snow. Feeding ourselves rice. Talking of her office. The watercooler mates. Instances in the market. Gambles. Ups and downs of personnel. What a word!

She's on her feet. I must go home.

Tonight is changing into tomorrow with that faint noise of rushing beneath the tongue.

I see her to the door. "Like a ghost she slips past me," the ghost of a movie.

Why must I be so constant to Dark, tracing its outline everywhere like a prisoner his shadow?

I lie down. I close my eyes. I fall asleep.

"Greenwood, tears falling madly down his cheeks, rushed out of the house. At the nearest cab stand he seized a driver and shouted, half out of his wits with sorrow, 'Drive me through the Park!' He tossed himself into the carriage and panting now, his cheeks pressed against the leather, gave himself up to that dream in which she passed before him in the room, the feathers of her dress gently touching his knee in the breeze of her movements and her perfume Horrified he noticed that the necklace was tightening around her throat. A small drop of blood fell and all that whiteness

suddenly He brought himself to his senses with the little strength that remained him and called, 'Driver! Stop!' The bent old figure turned around so that Greenwood could see his sickly grin and hypnotized Greenwood could not prevent that evil whip from urging the horse faster! faster!"

22

In the morning mail there was an invitation to a party. An opportunity to bring Miriam "somewhere." Into a world she assumed I occupied when not with her. One of our difficulties was that she did not understand my avoidance of this other world. My wish for solitude when not with her. I had taken the road to Provence. I so much wished to rub a little thyme into the russet of Dark. Nearly everything prevented me from this. My fear of the country and the natives.

It's all very well for Europeans to complain of the ennui of the villages; or those English travellers fearful of a night alone in the Alps on their way to—. Only an American has experienced the disassociations lurking in what was once known as Indian Territory. That is why Miriam had come to New York in the first place. Quite naturally she didn't want to turn around and return to—. Whereas I with all my fears imperfectly isolated was attempting to make a small countryside within New York City. And without taking a step beyond the city I wished to create a pinch of harmony. Alas.

"Come dressed as a perfume."

What shall I wear?

What perfume do you like?

You know I only wear the perfume you have given me.

And . . . ?

I'm not sure I like it.

Do you mean that all these years you have been wearing a perfume you didn't like?

Oh I liked it.

But?

I was never sure it was *me*. You understand. It was you who had bought it for me. Of course I like it . . . but.

But?

I never really had a chance to decide if the perfume suited me.

Would you like to go out and buy another perfume?

I'd just as soon go out and buy a dog.

What are you talking about?

I'd like a pesky, false, spoiled, precocious dog.

Whatever gave you that idea?

I want to go dressed as a dog to your party.

Then quite calmly she picked up a bowl from the table and threw it out the window.

23

Miriam was so angry during the next few days that I decided something drastic must be done. I sent away for a perfume.

When it arrived she was both enchanted and mystified.

Pêle-Mêle?

It's the way I feel about you.

* * *

Continuation of reality .

Prevention of ghosts.

Enjoyment of countryside.

Marcus Aurelius had observed: "How all things on earth are *pêle-mêle*."

24

Cousin Jacqueline is here. She tells me the rooms need painting, bits of ceiling are peeling off, there is a hole in the sofa, the curtains are dusty.

It looks as if you've lived here half a century, she says. And those sagging armchairs with shreds of paper under the cushions. What on earth have you written on this one? Doesn't your cleaning woman ever do anything?

Mrs. Blake has been cautioned not to touch my papers. At least she keeps the kitchen floor waxed. It's very good of her as one of my pleasures is to pass over the pantry into the kitchen on the smooth waxed black and white linoleum. Passing from palace chamber to chamber over the marble, as Miriam would warble.

The homely kitchen with the exposed water pipes. And yet it contains my small reckonings with the present: the dishwasher, the washing machine, the electric blender, the toaster. My attempts to lead the commonplace life in the modern fashion.

Moving her hand over the window sill, Jacqueline gathers in the ashy dust. Really!

But it falls every day.

All you need is a damp cloth every day.

Every day I stand looking out onto the park. Now the chestnut trees are blooming. White blossoms clipping the reservoir. Nurturings. Strung out passages. Light changing into Dark.

It surprises me that girl friend of yours with the uh funny name—what is it—Miriam, something foreign about that name.

Oblique Jacqueline. Turning the dish towel in her hands. Wrinkling her forehead, pushing back a strand of hair . . . showing her teeth.

Why doesn't Miriam, supposing that she comes here, and I'm certain she does, why doesn't she ever touch up this place?

Or does she have something better to do, I said to myself, almost enjoying this crude conversation. Then, as if carelessly, I

asked her, I've often wondered why you were called Jacqueline?

Now she blushes. Pleasantly. As they say.

I'm rather proud of my name.

Jacqueline? It's rather uh foreign.

A perfectly good family name, as you should well know. It comes from the French side of our family. The Huguenot side. To accent this she puts down the dish cloth.

Grouped behind her I can see her troops. The sallow skinned uncles with the yellow pigmentation under their eyes. Their broad business-like chests and their heavy hands. I've often wondered if they resented the ash of my hair. Or if peering out from above the circles of my eyes they liked what they saw.

Jacqueline and I try our nimbleness at this game, scurrying back and forth clumsily into the family past. Recalling embarrassing floor and plumbing. Until I insist on a recess.

I take her into my study to show her the portrait of Miriam. Foolishly I begin with, it's not so much that it's a favorable likeness, as that it is so like her, her mood.

Her mood?

Now I have faltered over that ridiculous word and she has caught me up. I am trying to say that it—catches the "spirit" of her.

She doesn't look very happy to me.

That's a new one on me! That's a new one on me, as Uncle Harry would say. I give Jacqueline a hearty family chuckle.

What's so funny?

And then suddenly I recall that wooden autumn when everything in the house I was living in was made of yellow oak, a surface I particularly detest. Nothing would move for me, everything lay embedded in the oak. At night I would try to put myself to sleep with fantasies of teak or mahogany. Or going deep into my memory try to recast the image of cherry wood which was my grandmother's bedstead. And all the while under the blankets I was being crushed by oak. Or during the day when I would turn desperately from chair to chair, caught in a kind of anguish I have never experienced, by the solid clutch of oak. Its yellow fingers running up my spine, until I would go into the kitchen for a glass of water to unstop my throat and there would be on the sinkboard

the grinning face of oak. I brought flowers into the house and smelling the oak they died.

I looked at Jacqueline. Her face was made of yellow oak. There were yellow rings around the irises of her eyes.

Get out of here!

Cousin Morgan!

Pack your bags and get out of here!

At last she has taken a step back from me. The oak varnish on her face is beginning to crack. Tears run down the polished oak stairs.

She runs out of the room.

At last I have been able to shut the door on that hideous house. At last. And I sit heavily on the broken springs of my dusty armchair. Miriam.

25

The scenes with Jacqueline introduced a few more quarrelsome episodes into my life.

I had allowed myself only so much freedom as would permit salutary and frequent excursions into Dark. I was aware of a narrowness limiting me to a few gestures, a raised arm of protest, a step taken hesitatingly on the street, a clouded voice, the tremble of the hand.

Given such limitations I had with an adolescent's presumption taken for granted that my forays into Dark—personal, paranoiac—but mine entirely, would have been greeted with sympathy even humor from my colleagues.

I was proved wrong. Those barricades I had erected which were nothing other than secret directives tempting me to discover here in the city a variation of haven—my own abstruse tree or rock, my invisible house in which I had placed forms which once consciously erected I could never abandon—these "barricades" caused such consternation among my colleagues that I was forced to stop seeing them. Or had they stopped seeing me? What if they did believe I had deserted them, was attempting to live a life without succor from them? What if they did disbelieve in the very grains of Dark garnered by me, separated from those colleagues who gathered in that great barn of a city? *"Dost thou think because thou art virtuous, there shall be no more cakes and ale?"*

Dark would be nourished. Without the support of L. who has begun his work on Grey. Or W. writing about Beige. Beige!

26

A plank falls. A piece of wood. It fell in the courtyard below. What distance did it cover? One piece of wood with its noise of authority. Sharp as the edge of a knife, but dull as the sound of wood. Strange that this means more to me than hearing from the apartment below first a violin then a piano concerto. These notes were continuing sounds, as a brace of thoughts or fancies. But the abruptness of wood falling. The ordinary values of what goes on near the surface—wood, steel, graphs, numbers, a blow. They cannot take us far.

Movements of sound across a given surface. Wood falls on a thing. Ceases. The music, I hear it continuing. A violin of the "soul." Yet the piece of wood falling causes a shock. Brings me suddenly to Dark. As if a thumb were pressing on my arm. No nearer. But certainly distinct. I felt it. It impinged. It was an accident, as the music that brings itself to me from another apartment, is not. And yet its octave did not make me shiver.

Who can relate sound? The garbage truck, the school bell, the helicopter, the siren, the brakes. Even a footstep heavy across the ceiling. And voices.

Miriam says I make sounds as I settle into sleep. I go um, um, these are the day noises I am shaking away from me as sleep which must begin as silence first touches the blanket, then reaches for my forehead. The ragged edge is hemmed with hum. Dogs go um um on the rug lifting their tails as the dream descends.

27

I don't think I can stand the noise of this city a day longer, said Miriam.

A boat passed under the Triborough Bridge. It was nine o'clock in the morning and we had been awake since seven. Carefully taking the weather's pulse. A jumble of gloom-dipped clouds, then that streaky red, sirens interrupted, the telephone rang, the first drop of rain fell.

There seemed to be no reason why I shouldn't go to a Travel Agency. I had never been to one before and had privately thought I would go when we planned a trip to Jugoslavia. Never mind. I took the umbrella out. Shook it in the air and announced I was off to return with travel folders.

Instead of going to the travel bureau I took a walk around the neighborhood. If I were to move, I mused, would I find less noise elsewhere? This was the question that gave me directions. Now if I were to leave this part of the city and move to another, would it be possible that somewhere hidden, the noise perhaps muffled by trees, there would be a nook, a variant on seclusion? If, for instance, I moved thirty blocks south, would I then miss the fire engines, the ambulances, the police cars of thirty blocks north? Or if I moved west, or if I crossed the river?

I don't think you know, I said to myself, how attached you are to your neighborhood. Remember when the hoots and cries were the noise of the river? Remember when a freighter narrowly missed the bridge and the scrape of that? Remember the narrows? Remember the silence as the river gathers its sand to enlarge the islet that each year grows before you. A child's toy. And yet, those shrubs are higher, they begin to rustle. Best not to consider moving. Shift to the easier compromise of travel. The fragment for the moment preferable to the intact papyrus.

Less noise could very well be located in the Caribbean.

28

Melancholy Mohair

It's yellow that's the difficult color. Mixing it with oranges and then getting into blue's problems. Whereas a straight green . . . I was on the escalator of what was at that time one of the most delightful department stores in the world. Not that I knew too many to compare it with, but I had tasted an assortment—a few had been despotic, not to mention the real trashy ones. In its best days this department store had been amusing, entertaining and filled with goodies. So today with a pocket of travel folders, an eager glisten in my eye, I gave myself over to the eighth floor: the designer's private hatchery of day dreams, "rooms with a theme." It was the best show in town.

After various titillations, including the dressed down chic of the Paris Apartment, I followed the line that led to the final room.

Dim, dusky, remote. Leather, ashes, palms, bottles, ivory knives, matting, rain, night. The dressing gown. The snuff bottle. The watermarks. Expensive and exasperated loneliness. I had to restrain myself from taking down the rope that held us off from the room itself and walking straight to the chaise. There it was. Melancholy mohair.

From whence had descended upon me this "Planter's Mania," I know not. I do know that I only read the other day about a Lt. Pinson who had seduced the daughter of Victor Hugo, Adèle, and this daughter had followed Lt. Pinson from the Isle of Guernsey (where her father had been exiled) to Nova Scotia, and thence to Barbados. Truffaut made a film from the diary of Adèle, an obsessive and mad woman who had followed Lt. Pinson through the alleys of Barbados, inventing her lies and fabrications of their life together. I never saw the film. My mother's name was Pinson and indeed the family had passed over from Devon to the Isle of Guernsey.

Did this Lt. Pinson return to haunt me—Morgan—was this the final spell cast by crazy Adèle? Who knows what caused me to stop there in front of that room and pledge myself to the planter's life—at least for the space of a few weeks?

Is all of this true, Morgan, asked Miriam, shaking her kind head, her eyes all but inured to *my* fabrications.

All of this is true, Miriam, and I placed our tickets in her hand.

"... *for in non other space*
Of al this town, save only this place
Fele I no wind that souneth so lik peyne ..."

29

I suppose what we're really doing is trying to find a way out. Miriam was bright and peppery this morning, having absorbed the Planter's Sauce the night before without experiencing too many disagreeable after effects. Or after words.

I suppose what we're really doing is trying to find a *way*. He was suddenly positive that this was the simple answer to most of it. As the way to Dark was distributed among his files and cards. *Der Weg*. He remembered the Philosopher's *Weg* in Heidelberg. Strolling above the town consumed with thoughts and difficulties, wondering if the pewter plate would be too expensive. Ripples towards Hölderlin.

Earthsteppers whose weird was to wander.

Now practically they must decide whether the way should be taken by sea or air.

Did he require preparation? If so the trip should be made by sea. Should they be given time to "change worlds"? Normally the answer might be, yes. In his case the preparations had been made so far in advance as to make an ocean voyage superfluous. As for changing worlds! Ha. Ha. Morgan, that old adventurer, that hourly pirate, that parader of parentheses, that parrot of vocables. He need time to change worlds! They might need the time, those worlds. Not he.

What are you mumbling? asked Miriam. Your mouth looks as if it were full of peas.

Which do you prefer, sky-blue or marine-blue?

Without hesitating she answered, marine-blue.

You've got a point there. The best sky blues he could remember and his experience was limited—he had never made the Northwest Orient Flight, or the Clipper Flight, or what was it they called the South Pole?—there was a very fine blue obtained at over 30,000 feet near Greenland, a sort of azure that might have been daybreak. The rest of those pale vaultings he would just as soon

miss. The yawnings at twilight like the last gulps of air before nightfall—it wasn't fair to call them blue. Especially with the tropical red dusk dropped on the plane's other wing. He would check that out. There were those Icelandic drifts in the clouds, usually over Arizona. Georgia O'Keefe westerings.

Pathetic his descriptions. They would never beggar the "whales way" or the "wine dark" sea. Even "marine" was a stingy cholestering.

And yet, one could not rest one's decisions on color alone.

Food? They had wasted enough conversation on that subject.

People? He whisked them out of sight. Their value was contingent, in this case, upon time. Time. He had already consulted Time. Or rather, had pricked his way about its sub-surface, world.

The solution was simple. Was everything simple?

They would take a plane.

Let's take a plane, said Miriam. That way we won't have to think.

30

This diary of a place . . .

W. S. GRAHAM

31

Dark, indeed, must always have been mixed with that planter's crop of dream and isolation. Surrounded by sea and palm. With the shaded house. The women in the house sequestered, the migraines with their raging heat and darkness. What was it like there on the land, the black astuteness hiding there numbly? Screens and birds. Rain. Looking at that planter's chaise in the department store, the chaise with its dark leather cushions and oiled wood. The evenings . . .

32

Night wind blowing from the north the orange curtains Miriam asleep sound of surf rain on the green sargasso sea. Miriam asleep dreams, they cross her face ruffled by the wind.

Leather planter's volume recording Caribbean thoughts. I read of island Dark, exile's journey. Century past mutterings. Crusoe diaries. So dim I draw the lamp closer, cutting out eyeside emblems like Trollope winter in Southhampton. The nearness of island old, centuries closing up closing in. An odd word or two like cutlass or grim kettle on the darkened hearth. A feel of damp leather and wool. Of darning resting on the wooden table. Horses mounted for the yearly ride cross island. Nothing so different. Always isolation. As in London on empty night Victorian streets. Outside the country paths empty. Until bird dawn when natives surround on turf or zoned road, commencing "work." Rain on trees, rain on cement; it all glistens. My imaginary planter's life corresponding with minor inaccuracies to the livelihood of Dark. Sybiline and economic forces at labor here or elsewhere in time. Going to dotage and pounds.

Space stretching around throwing out the arms wind crossing the room whispering its journey with nothing to stop safe to sea then on. Shore reef and ocean sand. Shifting the shutters before the bright dawn orange yellow dawn lighting the violet scrub. Soon the hills bright as morning buildings. Turning down the lamp. Place the book with watery type face down to preserve its watermark. Lonely planter's sleep.

33

There are more cheerful epochs in my planter's sorghum. That day after a swim another swim, a walk and several rum drinks we ate: baked snapper Miriam had "saved" from the cook by taking the fish from the oven before the usual island cooking time of three hours per baked fish; a delicate species of lettuce; a dish of young tomatoes; a dessert of mangoes with coconut ice cream and rum topping. We also discovered that the island sauce served indiscriminately on fish, meat, and fowl was delicious. Thus proving the French wrong and the English less so. Or rather that a combination of the two culinary disciplines is excellent.

Creole cooking is quite sufficient unto itself. At least on my plantation. However I must note that I am becoming addicted to rum. I think nothing of having my tot before or after breakfast and considerable during the day. Of course this has led me to a fuller and deeper understanding of the planter and his eighteenth century habits.

I notice there is considerable else that is also contagious on this island. Miriam "rests" for several hours each afternoon. She also wears less clothes than is usual for the lady of the plantation. She is becoming less cautious in her little household ways. She, ever so prodigal of houseware, thinks nothing of using a dozen cups and glasses a day. I even notice a scarf lying on the floor and a shoe kicked over.

"I wish the beach were really private."

Discovering fresh coconut ice cream in the supermarket.

34

Time to leave. A new dress put into a suitcase. Sun oil in the canvas bag. Idioms collected from corners. Winter garlands all the more welcome after this cohabitation with Caribbean attitudes. I'm wrapped in a cloak, prepared for fogs, ledgers in luggage, marshalled for Dark. Dark had only reached me here through squalls. Not from mysteries which are Attic. Dark smoked in my pipe. Drunk in the sorghum. Dark secreted from the huskiness. Travelling via vales and hillocks of the atmosphere, I began to reach toward that other Dark. Attic Dark.

* * *

The Weft

There is a dream of blood much deeper, much more organic (body and soul), which may become more apparent to whoever perceives that behind the gray and golden weft of the Attic summer exists a *frightful black*; that we are all of us the playthings of this black.

GEORGE SEFERIS: *A Poet's Journal*

35

I think of the sallow-skinned men shaving, bending over a bowl of tepid water, water brought cool to the basin, but now warmed by the already strengthening heat of the day. Men dressed in white pajamas, leaning over the bowl. Gazing out the window to a harbor. Then sun on the water and ships or a ship in the distance. A tree. In a house with plastered walls, a picture, a rug, a chair. Or a hotel room with bed, glass and table, by the sea.

These civilized, lonely aging, imaginative men. Seferis. Lampedusa. Victims in some way of the too intense climate. They were intended for another style, a severity, perhaps a French one. Yet the classical lines of their life are embedded in their classical lands.

Supervielle must have been of this company. Escaping by ship to France.

I revere these men.
Machado de Assis.
Morandi.
Lima.
Marquez.

36

Over the bridge and abandoned to the city. The infantry passes us by. The hobbled and poor greeting at the gate. The toasts lifted to us as we enter, toasts of scraggles and zarencies ferencious and disporging . . . (where no one speaks English) . . . we enter the impotent city like mercenaries creeping homeward to our hovels.

37

I want a home with five sane rooms.

H. G. WELLS

Life's cinema aspect. Remarked on elsewhere. It begins to unroll from my windows overlooking the city streets. There a man enters a store. A car turns left onto a street. Cars wait for lights. A bus stops. A yellow cab cruises. A light changes. The pace of the cars is faster. Slower. Water tanks top buildings. Windows cleave to them. A door is an entrance. A person crosses at a diagonal. A bench is empty. Someone sits on a bench. A person moves quickly. A person stops. Except for a parked car there suddenly is an empty street. I ask if this is a French, Spanish, Algerian, English film. The subtitles will give me the answer.

Above the heavy sky. Patches for breathing and light. Clearings over the bridge. Sun and storm. Evident at once. In the buildings people are hiding.

Adding one rounded teaspoon to the cup I watch these rooms swell, become beefier with age and experience. Henry had lived here while I was away. He left a few domestic remains. Customs which I now follow: apple juice in the ice box, garbage out at nine, a shower curtain. And a lot of laughs. They echo from the walls: "It's the same old syncopation, only now they call it Swing."

A few Goddams on the ceiling.

A boozy skidmark on the stair.

An ugly pencil.

"Great Cucamongas!" he used to say.

"Want some steamed chicken tonight? Hell I don't mind the cooking. Shall I pick up some gin? That Boojalay's a good buy, 1971. Christ, I've got to lose some weight."

He bought vitamins. He opened the Vitamin Chapter. It began

with his gift of a multivitamin. I'm now up to ten a day. Not to forget KH3 which I smuggle in from Europe. Henry left KH3 strictly alone after he had read the labels stating it was for an age group slightly higher than his. He understands correctly that his assets consist of physical strength, sexual vigor, and the charm of an extending youth.

When Henry was living here the apartment assumed some of this vigor. It certainly became less literary. Like KH3 he left Dark strictly to itself. Over the weeks he did read Wilde, I discovered, when he began quoting the Wildean aphorisms, his eyebrows accentuating the quotation marks and his smile moving in the direction of his thoughts which were that he was very clever indeed, especially to memorize so much. It had usually been numerals that exercised his memory, that is to say, telephone numbers. Now there swarmed about him the velveteen words of Oscar Wilde, and the name came out with what he thought was a perverse grin.

W. C. Fields would come chumping on. In fact Henry liked him so much even identifying with him in regard to martinis and noses that I could almost say Fields never left the room, at least while I was away. Later on after I had taken residence I would hear an offstage laugh and the shadow of the great belly, the puffy hands crushing—not peanuts.

Also after Henry had moved out and on my return, I noticed a healthiness in the atmosphere, not exactly a freshness, because even health carries with it a certain staleness, its efforts never quite used up. Yet the rooms did seem more muscular. Not so febrile and tenuous as under my occupancy. Perhaps another form of despair—since all of us are its heirs—but I began to enjoy myself in my own house!

I even got a giggle or two out of Dark. The rooms and I, in short, became less prissy. I suppose we entertained some of that youth which had been present. Even the desk which more than any other object had retained its personality intact, seemed to breathe more evenly; there wasn't that old atmosphere of task plus exhaustion.

So the rooms became more robust and muscular. Their some-time vacant expressions were overlooked. It had been like filling an empty restaurant with one hearty eater. Dimensions shifted then shortened. What had been secret became simply an unlit

corner. The sofa and bed came in for much use, likewise stove and icebox. Miriam's chair, her lamp neglected, had been shoved to one side. My desk was undisturbed, not so much from respect as disinterest. He needed only a corner of a table with the telephone and a note pad. I'm sure he rarely used his ugly pencil. All of the furnishings which he would call real, like lumber and its varnishings, went on in his head. In there dwelt a veritable Watts Tower. I'm certain.

I think, on the whole, things were enjoyed. Now I, I feel like a fire truck, a toy one with a new design, sparkling chrome, elegant ladder, modernistic hood. A Corbusier motor racing across my Bauhaus chamber.

38

The soul of the apartment is in the carpet.

EDGAR ALLAN POE

39

The Emperor Yang of the Sui dynasty was one of the most extravagant and lavish rulers we have ever had. He ordered many beautiful palaces to be built, employing all the finest architects in the kingdom, and covering the buildings with the most exquisite decorations conceivable. The most remarkable one was called "The Two Mysterious Terraces", and was divided into two parts: the eastern side was termed Mysterious Calligraphy", where many masterpieces of calligraphy were housed, and the western side "Treasure Traces", for the great paintings. It was our first real National Collection. By great misfortune most of these treasures were destroyed when the Emperor was making a journey with them to Yangchou, and the boat containing many of them sank in the river. After the fall of the dynasty the remnants were scattered and came into the hands of private collectors. Emperor Yang himself seems to have been a prolific art critic: he is reputed to have written fifty volumes on "Ancient and Modern Art".

CHIANG YEE: *The Chinese Eye*

40

So the days passed before during and after Christmas. The weather "held." The wind was "laid." Urban areas were little laden with drift or sledge. Canada behaved well. Winds from the north caused no dismay and a grateful republic was able to cross and uncross borders to the Commonwealth without unnecessary hazard. In fact, hazardous conditions did not prevail on the East Coast. The Central States, the Far West, had a few skittish days. But the Florida fruit crops were spared. There were along the East Coast a few Northeasterns: the damage was slight. Folk awoke in the early morning to white moonlight across their beds. Paring chestnuts for the Christmas turkey in the early morning light was like being inside a Dutch painting, there on Long Island with the horses grazing the flat belly of land and the potatoes sleeping inside their barns. There was a fine crop of oysters, clams, scallops. Those December days were like a Chinese Dynasty stretching and lengthening out seeming to cover many months of golden weather, like the trim on Manchu coats.

Although I resented the Manchu conquest, my heart belonging so permanently to T'ang, the weather was more Manchu, that is more leaf-strewn than T'ang; the weather was frail and friendly, wistful yet never furious, sometimes heard to whimper. Yet never in outrage. As the economy of the country worsened, so the climate became better. At one point mathematics and weather would join and at that epoch we might truly become a Banana Republic, having its diseases, corruptions, hesitating resources, beauty and breezes.

Welcomed here to the terrace. On the "calligraphic" side where the blown papers formed their ovals, like a mall. A pleasure to stroll it. Pick up a paper shred, peruse it and then toss it like a ping pong ball over the side. Associations distributed by the winds of chance.

Today the torn label PIWO OKOCIASKIE, a bright Czardas

figure, her skirt mysteriously ripped, Chopin's Polonaise on the troubled radio station. Further on I read FULL LIGHT: O.K. BEER. Is that a light from Warsaw? Here at this once great port, this immigrant's haven, the ashes of which have fallen onto my terrace? My terrace of calligraphy. Or should I call it my Treasure Terrace? A shard of robin's egg, the Cardinal's feather, the Irish moss between the stones. And my pitter patter as I chase false clues and compute those future tests.

Merry Christmas *from* *The Whitneys*	
WE	THEY

41

In those days I often felt like Gogol carrying his musty portmanteau from darkest Russia to golden Rome, my portmanteau of Dark which, like Gogol, I nudged with my toe in the carriage to claim ownership. It was a burden that permitted me to slumber, but never rest. A few triumphs but never pleasure. Or rather, pleasure infrequently yet never joy. If my heart were warm my toes were cold. And Dark with its passages, its passaggios, its allées, grottoes, ha-ha's, its Alexander Pope festoonings of nature and Walpolean equivalents, its Beckford mice tombs, without any commercial instinct, was difficult to preserve.

Like the Duke of Bedford I considered charging admission to my Dark Park, but the animals were too obscure, their rituals private. I thought of inventing a Buttery for Dark, where maidens might play at bucolic, but the ink of Dark was blacker than squid, no milkmaid would stain her fair hands. I thought of a bistro for Dark, but the inhabitants would be too aged; "aged in wood," no doubt would be the remark on observing the walls. Or hiring an economist from Malay.

And so my terrace throughout the winter felt the tread of Dark. I tried new syllables on its brick and a syllabic institute was formed beside the railing. Dark commenced to smell of the outdoors rather than the cloister. The arc of a pigeon wing circled Dark and an acre of high-rise building was its environs, or environment. Dark entered the air. Became more spatial. Rhythmical as the sun rose and set.

As the rhythm rose and set I noticed a Montenegrin beat. All the great Jugoslav poets are Montenegrin? High on a mountain top carrying on the tradition of the bard. Primitive music and epic thought in a harsh setting. Bearded one chants by fireside. Definitely a Montenegrin strain in Dark. Furthermore Dark was enjoying the heights of my terrace. The bean had become a stalk and up climbed Dark, over the rail, to pace in Montenegro.

I had one other consolation. At least Dark would never be mass produced. There was no Montenegrin market in this country. Moreover, while we were all living in lean-tos and shacks Dark's supple discrimination might—and Dark's equipment might—. I had come to the last brick in the walk, the turn in the corner, the end of the day, the last day of the year. And still no snow.

42

> . . . he said that death had something
> peculiarly triumphant about it . . .
>
> NADEZHDA MANDELSTAM

As I check my charts I notice the health of Dark rising with the equinox. Its breathing less anxious and the eyes opening wider; the eyes were beginning to see with an acuteness that even I could not help admiring; the objects, people, atmospheric attachments, ephemeral persuasions, making their exits and entrances. Dark was even more microscopic as the tensions within its own regime loosened. What was being bestowed with this ragtime of health was a resistance even an imperviousness to Death, which meant to the ideas of Dark the death of the image of Dark. This death which had loomed so hard upon the enclosure of Dark, between the covers of its pages, this death which had sought to smother Dark's imagination, its nobility of purpose and hope for the future which meant the extended horizon of its art, now became enfeebled.

The terrace so narrow, so primitive almost, so undecorated by shrub, canopy or flower, so plain amid the resplendent city terraces was giving Dark its great exercises, its lessons in the survival of the word, the image, was even within the contract space giving Dark a location so that its wings might attain a gloss, voices might be heard, fancy might later attain a gaudy bloom. Dark was becoming victor at last over the persuasions of Death. Death's triumphant entry into the life of Dark had been interrupted: there was a reallotment of power through the dithyrambs of the terrace.

(Adjacent Memoranda)

My going off to sleep during Miriam's party was one of many instances when I tended to refuse her a role, rather I would go out

of my way to avoid seeing her in a role selected by herself or her friends or the house in which she appeared. Hostess was a role I especially disliked. I permitted the Claudinehood because that entertained me. And somehow it amuses me to see her, as it were, with the ribbons tied behind her frock, the shining patent leather shoes, the childish locket. This is perverse of me and I wish I could get rid of these scenes from another decade. I should not place them on a person remarkable for her flexibility.

It has been noted of Karenin that:

> "not until the storm is about to break does he actually concede that Anna might have her own destiny, thoughts, desire . . ."

My "chauvinism" had taken shape differently from that which I had observed among my peers. Their attitudes were ones of convinced superiority succumbing to subordination, frequent rage alternating with social and sexual needs. An acceptance of their malehood as a natural state of grace was taken for granted in a world whose laws were created by and for men.

My attitude toward Miriam was interwoven with my preoccupation with her as a person whom first I had discovered and then one who I believed I might recreate in the image I desired. It can be said to my distress that I never let her alone. I persistently meddled with her character. I left her only to solitude. When with her, that is in the same room with her, my imagination infused itself into desire.

Osip Mandelstam's wife explains this state quite clearly when she tells us that Mandelstam's endearment for her was "my you."

* * *

> may be a wholly unanswerable question—though certainly many women must have asked it to themselves, and decided that they had to accept that that was the case. But even if an answer is, in principle, to be had, it is only to be found in the inner recesses of John's personality. So it is no longer accessible to us now: and perhaps never was, in practice, to anybody.

As a personality, Ida comes across most
clearly in the book—no doubt because she
to excellent letters. She was very loyal
suffered greatly in the menage
suggests that she

(page torn from a book review: *The Listener*)

43

Now I understand what is meant by "he's forgotten more than you'll ever know." So much have I destroyed in the name of Dark. Fæces of knowledge, asterisks of learning have been blown up like bridges in this concentration on Dark. Faces, too. And geography. Where did that year go, and what went with it? I have only a scrap thrown over here. A decade seems to have blown right through my head leaving wisps of coloring, and a few nasty vapours. Was it gentle? Was it kind? Only Dark knows the color of its hair. Even the Attic figures destroyed.

44

Yet one should not forsake the melodic line. It rests here like a cloud, there like the blue. Because it can be overheard it should be listened to. If not regularly, then intermittently, but a certain constancy should be maintained. And that will chalk up the memory account. Something like a postcard remaining of a visit to Spain. But sufficient. Like geometry, perhaps. One recalls only the isosceles passage. Yet geometric figures cling to a life, fortunately without one having to take any particular notice.

As I said to Miriam yesterday in the restaurant: Didn't we have the lasagna last week? She reminded me that it was always on the menu. I last had eaten the lasagna a year ago with Dorothy. A woman even whose name I had forgot. Yet the lasagna presented her vividly. A tall, tense, orderly woman with quick strands of red hair. We had eaten the lasagna at the beginning of the year. Why exactly a year ago! Between Dorothy and the lasagna what areas had been trespassed! What exactitudes! Exaltations! Salutations! Grievances! Accordances! Furniture, Problems, Illnesses, Invitations, Restitutions, Embarrassments, Harrassments, Conceits, Auguries, Sentences, Journeys, Slights and Sleights, Vanities, Regrets, Love, Sorrow, Death.

Reflecting the tact of Bellini's Norma, Miriam, sensitive to the palate of others, had suggested the Osso Buco.

45

I found these Transportation Regulations for the Sheridan School, Grades, I, II, III in my pocket, in the jacket I had worn on that last trip to Washington. Placed there when I picked up my nephew, Neil. The second column was my own addenda.

In case of illness or absence for any other cause, please notify the school as soon as possible. In an emergency in the morning, please call your driver between 7:15 and 7:30.

After the school is notified not to stop for a child who is away or ill, the car will not stop again until requested.

Parents are asked to enforce the school regulation that children MUST report in at home when they return, before going out to play.

The regulations for good school car behaviour are carefully explained to all children. If a student is reported a second time, a letter is sent home to the parents. Should a child be reported a third time, he may be excluded from the school car for an indefinite period of time. We are proud of our fine record of student and parent cooperation.

expectancy, forgiveness, betrayal, detective stories, paintings, lights (electric) buying paper, pens, postoffice, heels of shoes fixed, the river, the sun, traffic signals, traffic highway directions, school terms, licences, hospitals, (someone who whistles) a mirror, a desk, an ashtray, a glass of water, a door closed or half open, a closet a broom, stairs, windows, bathrooms (people going there) Pablo Neruda, they had no choice but to live alone at isolated points, slashing away at the flint

turning point the quilt, the telephone call, memory, forgetting, landscape, lack of landscape, buying, buying clothes, objects, money, reading old biographies, old novels, walking, oysters, movies, trip (today-tomorrow) memoirs, letters, history, anthropology

46

Why shouldn't I treat myself to a little high, thought Miriam, reaching for one of Morgan's Darvons. Watching a caravan of clouds like camels walking across the sky followed by their flocks of child camels. Once I would have said "Reach for a Camel, instead of a treat."

It is also a rare treat that Morgan should leave his retreat and go out for a walk leaving me alone. She stretched. Clasped and unclasped her silky knees, then moved restlessly about the room. Forgetting the camels. Lovingly she smoothed a circlet on the pillow where his head had lain, and tucked in the sheet where shortly before she had lain.

The clouds were reflected in the camelhide water of the East River. The sun was setting somewhere behind her back, probably in front of Eustace's building. All she could see of it was a reflection on the Florence Nightingale Nursing Home which had lately come under attack for mismanagement. Strange, it looked such a handsome, qualified building with its new yellow bricks, canopies and wall-to-wall windowing. Often as she pulled down the Venetian curtains before taking her place beside Morgan in the bed she would wonder if perhaps the inhabitants of the nursing home would enjoy a little treat of watching. Morgan was very strict about that.

Isabel, he would say, I don't permit others to watch my oriental pleasures.

Yes, Mr. Burton, and scooting across the bed she reached for the cord to lower the blind.

Reached for the cord to lower the blind, she murmured.

How crisp that skewer of air was under her toes.

Delightful the way drafts managed to find their way inside the room. They attacked from all angles. Particularly as the apartment was composed of angles, the best angle freeing a part of the room to view the Triborough Bridge.

Miriam finally settled down to read *The Poem of Hashish*. Well she remembered the building or "hotel" in which the events narrated in the story had taken place. At the tip of the Isle St Louis. She kicked off her shoe. She had been in that very room whence issued those smoke curls. So had many tourists. She kicked off the other shoe and heard Morgan's key in the lock.

He entered bringing with him the sound of the elevator and a bottle of Scotch.

Before setting his parcel on the table he kissed her.

I have missed you terribly, he said.

Do you realize this is the first time I have been alone in this apartment in—

I do. And how do you find Dark?

Only a whisper and a scent.

All in good time. Enough for the chapter.

47

(The next chapter drew its source from Miriam's fingernails.)

Toward dawn waking and finding her hand outstretched upon the coverlet.

Regarding the fingernails. Including the cuticle. Their slenderness and length. Like the Ptolemies. One, the brother of Cleopatra, cut off in his youth. Then the elegance of their curve, the clumsiness of a blunted arch, a buried difficulty somewhere a
. . .

Farmers scratching in the ravine there where the finger's lake currents washed across the pavillions as in a village where walk the country girls lake casting everywhere the pine scented air of Sochi.

Disorder. The dressing-room of a star of Kabuki. A smear of paint, a rapid twist of glue, a forgotten article hanging almost in air and the beautiful disclosures waiting to be uttered outside . . . fingernails sliding from the wrists like sleeves. Like your head turned sideways on the pillow the dreams inside lifted from the skeleton squalor—like fingernails separated from the body's squalor.

The concentrated rhythm of an only child.

48

(Does this have any correspondence to the Powell boy's discovery of who the sheep were in Westminster Abbey?)

Miriam,

Today, Sunday, I find I can no longer sing "Ancient of Days." In fact I can no longer sing more than a few notes of anything. It was the strep throat that did it. I remember going to the theatre (an adventure quite easy in those days) and feeling a sudden chill. I returned to the apartment and then found my way to the Cranes' apartment where I was ill for six or seven days and they took care of me. It didn't matter that I slept all day in the living room where my cot was, with their continual stream of guests black, white, orange, whatever, resembling the furniture, heavy warehouse remainder, together with the Tibetan scene on the wall and the Chinese lamp Father brought from there in 1903, passing in front of me and I heard their chatter in various tongues and lapsed into a delicious non-participating revery of the best, lying flat on my back and not having to utter a word. It was there my voice or whatever registers of it necessary to sing departed me. Now when I force a note as this morning with "Come thou almighty King," I hear other languages, other sights are condensed into other sounds nestling in the four walls drapery patina and all that protected and succored me to health, missing a note or two.

49

I don't reckon I noticed your car parked there, sir.

Why does he talk like a goddamned stage American thought Morgan irritably. He's just smashed my fender and now I have to go through the bother of insurance forms and more conversation with this blighter. It was catching. There they stood on the street corner like two toffs. And the bloody snow was steaming down and he'd forgotten and left his muffler home. It was enough to put your eyes out what with having drunk a bit too much the night before and seeing her home in the early light with the rain changing into snow. Why didn't he go to Trieste or Zurich or ring cowbells? And here he was dropping his bloody gloves in the street and the man just standing there looking at him. He had known that car would be more trouble than it was worth when he bought it. But they had thought it so necessary to take them back and forth from the country. What country and what back and forth? He was going to have to sell the place anyway. And all because Dark was becoming so expensive with typists and alerts and research sending him to the odds and ends.

Why don't you give me your card and your insurance number and then we can settle this later. It's too cold standing here on the street. I can get the car to a garage.

The little man was grateful. He ought to be. He was getting off easily not to have bumped into a cab. But Morgan hated encounters such as these, even when damage stood to be righted. He accepted the man's card, his thanks, took the licence number, the driver's license, and was left as the man drove off, standing on the corner with a smashed fender and a small scar across the back window.

Yet somehow the time consumed had been worth it. The grocery stores were probably closed by now and he wouldn't have to purchase the victuals. God how he detested that word when his grandmother had used it. But now victuals and meals had become

favorite, patronized words. Their clumsiness and vulgarity appealed to him. Victuals, of course, might be Victorian, but meals had a fine Anglo-Saxon turn to it.

Oh get some sole.

Not fish again?

It's thinning and full of protein.

Sole had been the soul of the novels he had consumed. Dover sole and sole Marguery and sole at that discreet restaurant dining with Rex Mottram after all Brideshead was lost; nearly important as *en daube*. The number of *en daube* meals eaten in English middle-class novels. But eggs took the high honors. In an emergency eat an egg had been the motto. Get thee to a nursery! Hundreds of British heroes and heroines tapping "the thin shell of an egg." Eggs for breck, tea, supper. Rushing off to the hunt, in front of the fire, in the chafing dish. Oh don't bother I'll eat an egg. No bother, have some grizzly bacon drippings. And the grizzly egg sops. Even eggs caught on the tines of a fork! Cold eggs were often featured to introduce a note of pathos, or the last sad sentence before the end of the chapter.

Why hadn't American novelists caught onto the habit? There were breakfast eggs, but never plover or quail or "running up an omelette." American novels were too full of regional food. Grits! And his heart hungered.

He'd better get the car to the garage before the wind thickened.

Alas, he apologized, when Miriam opened the door. I haven't bought the things. An idiot banged into my car and the stores were closed.

They ate the silent things that had been patient in the cupboard. Waiting "the right moment."

Quenelles in a can, brandade de morue from a can, black cherries, Mexican chocolate, white asparagus that had been in the back of the ice box for God knows how long, still the bottle hadn't been opened. The food came from all over the world and tasted as if it had been travelling a long time. They drank Red Label Johnnie Walker. Morgan read from off the bottle where its awards had been bestowed. Sidney, Paris, Adelaide, Melbourne, Dunedin, Jamaica, Kimberley, Brisbane. What a history of empire building! Jamaica 1877! Probably tippled by one of the Robert Brownings.

And now having *terminé* our geographical deenay it's off to the flicks with you. I want to catch the *smörgåsbord* in *Scenes from a Marriage*.

50

And so instinctively he, Morgan, left her and his feet took him out into the snow while she, Miriam, waited at the door, her hat on her head. Wasn't it her turn to leave? But no, even the farewell must belong to Morgan. The hello at the doorway, the how are you, once inside the house, and then the goodbye, all, all belonged to Morgan Flew. There was her soul which once even she had thought chastely bound to herself. But now she was not sure. Even it had begun to feel tears and shreds at its seams, gradual thinnings in the garment, and of course out at the elbows. Her soul. Perhaps the workaday world belonged to her. Where things grappled and had whims which began in the corners of the market and ended up under drawers, or inside briefcases. This workaday world might very well be hers.

It had no good morning or evening. Merely entrances and exits. Comings together and separations at glass doors or within elevators or on carpets. A title skimmed through her head: "The Magic of This Summer". But that didn't belong to her either. It was the title of a poem written by a friend of Morgan's. Why hadn't she the good sense or taste to pick something popular, out of public domain, like "white is the color of my true love's hair." The snow was coming down in thickets. Thickets were forming outside on the terrace and the night was squatting there white shawled. If idly she were to go out onto the terrace and from the snow take a snowball. A snowball and hurtle it through the air. Could it truly be said that for a few seconds that snowball had been hers, the choice had been made freely by her, Miriam, to throw it into the air? Or would Morgan when she told him what she had done, would he create another action out of hers, would he call it a performance, would he make of the terrace a stage, would he deprive her even of the scenery by causing a scene to take place between the woman alone on the terrace and the snow held in her hand?

51

Two Descriptions:

Dark and Light
Train sequence

green windows on right
clear glass on the left

As in a railway coach with one side dark green glass windows, the other a glass of natural light. Foliage and sky—green side foreboding . . . anxiety . . . the other brusque with natural hue.

When the sky darkens the clear windows attach a sadness. Artificial darkness of the right is rather exuberant, like an exotic island. The irreality soothes when night comes down. Fringes of trees appear quiescent. They have no subterfuge are shadows in the green light.

Now on the left falls darkness . . the threatening quietude of Dark. The mystery goes deeper. All natural forms breathe with fearful sighs in the darkness

green windows
clear windows

In nature this breathing takes several gradations from high to low as the light loses it contours.

No loss under artificial light. This light creates a *permanence*, a green absorption. No sky wash.

Thus nature retains a permanent tension under artificial light. To which do we adjust?

The lapse between—the contact when the real and unreal resemble one another. Only we can compare the one green with the one blue. The sky egregious . . .

52

Yuletide Junketings around the December logfires.

SIR ARTHUR BRYANT

We'll have a Sunday grass picnic. While it rains on the terrace. Snow melts and words fall into place. A most delicate place that where we dined. We two. In the half-dark. With the slit of light appearing through the twilight. Half and half we two, up and down. Settling on top like a teapot dome. Two branches of the tree thinning out. Tea. The simmering part. The harvesting. Leaves being caught in the net. A carapace where my shell had been.

Balls hanging into place. With perfectionist eye noting, school to school, the Florentines opposed to the Veronese, or the early Byz, especially they, related to Cretans and Egyptians and the almond sized an addition to the camera of Marco Polo. Shouldn't they hang a little more to the left?

Shouldn't they be tucked in a few inches, or an upward curve. Shifting the weight.

As in my parent's house, shouldn't we knock down that wall?

Miriam, a few weeks from now you'll ask, Why are they so high? Shouldn't they be lower?

53

The day that had begun so hopefully with exercise, coffee, yogurt, newspaper. The day that was to banish his dream of the beds and the German—could that have been von Hofmansthal—another of his death dreams—the day turned into rain which the optimistic might call spring rain. From the window he saw a figure crossing the street under an umbrella. It might have been his mother, walking, as always, alone. He tried to read a chapter on Greece. "There under the glaring sun the statues had stood for centuries. Despite her motley attire today Greece once . . . "

The islands floated up under his eyelids. Space began to flicker, vacate, enlarge. He called upon Dark to enter the shadows. His eyes ached with the dinginess that was beginning to intrude. Morning trials testing the strength of the previous day. Yesterday's beauty faded. The bloom fell off, he tried to catch it.

Turning on the lamp he addressed himself to shadow and what had been thick there beside the sofa slowly shrank until it was wisp, a mere wisp of sorrow. Morgan breathed deeply. It's true, he realized, one does shorten one's breath under stress. The relief was arriving with his breathing, with the light, with the disorderly puddles on the terrace. He watered his plants and waited for the next hour to arrive with its machinery.

54

Chasing March hares. Miriam started twice to telephone Morgan, then hesitated each time. Out there in the smoke fog fetched city where each piece of grey was winding a tendril around the other, where windows were losing their contours—"*le contour me fuit*," repeated Cézanne—was Morgan Flew at his desk. Shuffling pieces of paper. Just as she at her desk was moving empty white pages back and forth until what was now wan in them became reflected in her face. A pallor descended from ceiling to floor brushing her. What is it that eludes me? What? An essence, a substance, a grasp where things were formed with clear outlines and solid weights and firm indentations. Morgan's Dark had its weight, value, even its variability dependent upon the diet Morgan fed it. This time she finished dialing his number. The telephone rang six times. He was out. She was here. Here. Here. Morgan! The telephone rang and it was Morgan.

" . . . I thought we might have dinner at your place?"

55

It was like driving a ball from behind that clump of grass. As if he were continually in the rough. Never reaching the green soft clipped grass over which his golf ball could purr. From his father he had learned about golf and he owned a snapshot of his father in knickers, smiling with his hands on his hips, looking down the Florida fairway beneath the sketch of winter sun that had promised much to the golfers with its brisk added clouds. That was how he thought of his father in his happiest mood. And now the voice kept repeating as it had over the telephone that morning: "I don't know what to do." A lean whimper like the greyhounds his father had also pursued at the track.

His mother in her widowhood.

And just now Jane's voice over the telephone. "He died on the street, walking his dog." The great painter had died that morning. His father had died years ago. His mother kept repeating she did not know what to do.

Anne in her widowhood.

Were they, women, prepared for this from earliest youth? The lucky ones?

Whose religion was responsible for the voice that came "from beyond the grave"?

The painter of interiors and lawns. Of incorrigible silences.

The pleasant sportsman, his father. He had died.

Both of them dying with the early Fall. *Indian summer*. How beautiful those two words had been to Morgan carting his suitcase from station to station in foreign countries. Like a family secret.

Sombre words, also. "September Song." The "vintage years." Forever the painter would be remembered by the elms, the thick elms he had painted. Morgan would drive by them remembering the shadows they had cast in those paintings. Memorials.

What sentence had been passed over the painter to send him to his grave, unexpected, with the ripe shagginess that mantled him?

Bleeding to death in a Florida hospital. That had been different. The mysterious mosquito and the drunken doctor. A folk story to be repeated about that shoddy South his father had loved.

Morgan lighting a candle at early mass in St. Dominique's. As in Perpignan. A candle lit for Dark. A candle for descriptions in which art finds itself enmeshed. The thirst was at the base of the tree, not in the shuttering leaves. On the way to the funeral train he entered the Museum and went to the French paintings. It was true. In the Twentieth Century the masters had concentrated on the trunk, not the leaves. Matisse had passed many years studying the tree at its base. The base would shift, almost idly, then formidably.

"I don't know what to do."

Facere. "With bandaged hands," Morgan had written the summer he had lived in the painter's house. He had touched everything with "bandaged hands." There had seemed to be wounds all about him. It began with himself, of course. The sea noise coming from the East starting at the top of his head as he lay on the harsh mattress, then it groped over his body he tried to shield with his "bandaged hands." The breakers, that was what they were, from the sea a short distance away, breaking over his body, entering the house from the long windows, rolling down the staircase, into the large parlor, the winter parlor, the dining room, brushing against the pictures, wounds starting up wherever touched and bandages placed by him each morning, bandages rolled and unrolled with his own "bandaged hands." It was Death he had been struggling against, using up the linen cloth and the sterile tape. Struggling in his dreams. He had thought once he had seen a drunken soldier leaning against the lintel of the fireplace. He had heard boots in the hall. He had slept shielding himself with a quilt from the racing nightmares.

Prayers lighting up the morning rooms. How grateful one was to their verses written in the peasant colors, tacked onto the wall of the kitchen. The cradle song in the third bedroom. Traces of vine and rose where the wallpaper peeled.

Morgan shook and stammered and shivered with the desolation that overwhelmed him as the chapter ended. There he remained with his vocabulary. Who would inherit the painter's brushes?

He could see from his terrace people walking along the sidewalk under the young maple trees, two men in raincoats.

56

"The dull despair of an old villa . . ."

I don't see why we have to drive out to your parent's house in the middle of winter, said Miriam.

Simple. It's the only time the house is empty. In summer, as you well know, we rent it.

You are jolly good fond, très amoureuse avec, that house . . . n'est-ce-pas?

I really loved it when I was a kid. Growing up there. Then I believed the house had resources.

I envy you. The continuity. Everything from my childhood is destroyed.

Except you, Miriam.

(Describe trees, road, expressway, cars, stopping for gas, towns like Bluepoint, the insane asylum looking like nineteenth century Bedlam, the new suburbs, mileage aspects such as the shortness of the drive as compared to a few years before, traffic and comparison of traffic zones, the atmosphere of the various expressways.)

(Memories. Taking the 4:19 from Penn Station in 1930, as opposed to now, the same time schedule: discomfort and dirtiness of trains as compared to European trains; comparison of parlor car with coaches; story about the man: "I think I'll go into the parlor car and get me an old-fashioned," with heavy mid-western accent; amount of drink served between Jamaica and Montauk; early days driving 1930's again; before that taking the boat to Sag Harbor and hiring a carriage overland to East Hampton, I bet few people could top that one; my grandmother landing from Europe at Montauk and being taken by carriage to East Hampton; there are some people who can give variations on this, but fewer each year.)

(End discussion with the terrible places to eat on the highway.)

(Timing the arrival. I remember when it used to take four hours. Two hours now, or less, if the traffic is "light." Best to go on off-hours. The

trouble is I never know when my off-hours will be. Miriam always eager to create an off-hours with an off-hours cocktail before proceeding.)

Upstairs in my bedroom trying on the aged clothing that returned youth to the atmosphere triumphant for a while, a moment seized from the day, barricaded by the weather and a slight feebleness of limbs and nerves.

Lying in the grandparent's bed under the purple quilt, Miriam watched me, her hands touching the bottom of her white cable-stitched sweater that shielded her from the redolence of the room where it stretched tight from window to wall, the crispness of the outside air.

Miriam reading Marie Corelli.

Thelma! Thelma! she sang out. Later I had the iceberg dream and a field of stalactites frozen in the far north where the northern lights were zodiacal constellations. Participating in dreams with Thelma on her travels from Norway to Milord's home in an English county.

Downstairs the poetry books lay on the table. The chicken soup waited in the kettle. *Un peu de farine.*

Under the eaves the sparrows fluttered and fucked and fed their young.

It was idle hours in the old manse.

The train whistle. I believe that I hear strangers in the house. Investigating my mother's bedroom. The chintz bedspread with yellowed gloves lying on top of a parcel. My father's cane balanced against a chair. Photographs. Me. The stranger. A dog barks. Miriam calls. Her voice echoes down the hallway. The smell of mildew and sea. Camphor and one's entombed youth. Just like everywhere. The space so occupied by memory, so empty of life. The sea prowls the shore. The sand plunges. Betrays new shells and molluscs. A fresh sunrise. Tomorrow . . .

The Telephone! cries Miriam.

Where is the telephone? The upstairs one? Back to my mother's room. The old black telephone beside the cream "French" bed, beside the creamy gloves, inside the hollow that is cream of my youth. You dun-colored Morgan.

Drinks across the road? I call to Miriam. But it is my father's voice. Drinks, divine one, across the road?

Yes.

Shit.

What did you say?

I said . . .

Yet it was in this house that I found Dark.

There was a strong wind, nearly a hurricane and the wind came from the South. The mulberry tree fell and I thought I could hear gusting through the radio the crackle of electric winds. It was the year we believed in herb tea. A door blew open and hundreds of dried shriveled herbs and stems were scattered. It was the denouement of the herb summer. We began to listen to Quintets. Dark crept in. Not having any particular place to stay it allowed me to adopt it.

(Dark) (Obbligato) (*Nunc einem in domine regnum*)

And a darkness fell. At the wretched age of fifteen to stub my toe against it. The same toe I stubbed at Olympia on Hera's tomb. Wrapping my chiton upon me I groped, stumbled, stubbed, sprained, spit upon Dark's obbligato. I drank it in. A tricky business opening the door. Expecting a visitor? Are you kidding? In this wind? Well there's just this bit you haven't finished, there at the margin, at the first chapter, probably in code, or ink smudges like the papyrus of Archilochus, unable to decipher, "probably an ink-blob." Whatever happened to "demure academic jokes"? They got lost in the dark. However, there were enough "substantial and charming fragments" hid in the closet of Dark to last a lifetime, one wishes. Although our meeting was abrupt, opening the way for high philological erudition, Dark mumbling away about Grief and Despair caused me to bring a halt to our expedition. This halt lasted until I was twenty. Then again almost by chance I wandered into Dark's quarters here in New York. This time we "finalized," as the White House says, our acquaintanceship, and the heat was on.

Is there any place to dance around here?

Conversing with and about Dark I was caught off guard by that question.

There's a place on the main highway. For kids. "The Moon" not too far away. Arabian Nights décor.

I'd like to go somewhere I didn't have to pay for the scenery.

We can do a quadrille by the sea shore.

That was straight out of Dark's book of humor and absurd

conceits. Such a remark was certain to irritate Miriam. First she bristled. Then she drooped. She sank back into her chair raising her foot high. Like a little flag. A slipper hit me on the ear. I needed it for Dark's boat, but I knew I must return it. So I did. "In kind." Now after bristling and drooping she was scratching her head where the shoe had hit.

Morgan, there are days when I think I'll leave you and Dark to fight it out together. The enemy is going to retire.

There are no secrets in our ménage. Miriam understood very well the direction my thoughts were taking. That about finding a place to dance was a decoy.

One can summon nostalgia about a place one doesn't even like. I dropped hints about the beach. Ah the beach in winter. I wanted to see what ruins lay there. There had been several trouble spots, such as the beach which always eroded, the beach of gulls, the beach of broken bottles, I wanted to revisit. So hatted, scarfed, and buttoned up we issued forth.

Sure enough the Villa of the Celts was deserted. The stucco fence was crumbling. It was obvious that the villa had insinuated itself into the end of an era. Yet the Villa of the Huns, being permanently let, I had been told to the Persians, had new paint and as I carefully studied it I perceived new weather stripping about the windows.

Miriam said, Weather stripping is expensive.

(I was wishing Dark might be translated into Persian. That would pay for its keep. And then some.)

I wish whoever had the money would keep the beach cleaner.

In that case she was talking about the township, for to the best of my knowledge the Persians had chosen to ignore the beach. Oceans appeared not to interest them. And why should these people brought up on the rim of the desert, partial to oases, bring their regard to the sea. For other than merchandizing purposes. The villa was a mere jumping off place onto the power centers of the city.

(I must really strike some sort of Bargain with the Persians, for Dark's good. Dark would gobble up those Persian fairy tales. And the Persians might find a new slant on men's affairs in the ramblings of Dark.)

Yes it was a waste to throw the ocean at them. Argentinians landlocked were very lenient toward oceans, especially Borges

who went around dropping crumbs from Beowulf on any occasion. There must be a whole generation in Buenos Aires busy with Viking maps and mead halls.

57

In the city we resume what Nietzsche calls, "the impoverished life."

Restricting oneself to a certain neighborhood, vegetables, early to beds. Conversations, unfortunately, also restricted. Communication lines fluttering in the breeze, or at night so brittle with the cold they snap.

I notice the different sizes of my handwriting. This week it has been especially small. There must be an attempt to exercise some kind of control over myself when the anxieties arise which affect the weight and size of my handwriting. As these anxieties proliferate the handwriting becomes smaller. When free of fears the writing is strong, medium-sized and agile. Suddenly more erratic sizes take place.

The particular anguish of the "impoverished life" may be prompted by something so unpredictable as the weather. Much research on the symptoms arising from meteorological changes taking place in Germany and Switzerland. Along with the religions of fasting, nude bathing and vegetarianism. April is extremely cold with snow falling in the suburbs. Then today we had a snowstorm.

58

Walking to Shay's studio in the snow. From her basement emerged a woman. Babushka. A shawl wrapped around her shoulders. Snow fell over her face. It was 1880. Vienna. Prague. St. Petersburg. Snow shows its immigrant face under the lamp-post. A city loses its continuity in the snowstorm. Becomes the age of snow paintings. 1880 in that neighborhood of Beaux Arts townhouses. Some frescoed, like Heidelberg. The snow. A Japanese walks towards me. I perceive how bowed his legs are in his dark trousers surrounded by the white snow. All silent and figurative. I want to embrace Shay in front of her door. The snow falling on us. Hiding her face. Only four arms bleating against the fleece of the snow.

"Are you cold Byzantium?" asks Mandelstam.

59

Watching the woman move about the room from the mirror to the cabinet, shifting her skirt beside the chair, tearing the lettuce leaves, the stir her hands made as each graceful air followed, the man sensed a change in the direction of Byzantium . . . Gratitude followed that the strength from this woman, that of her newly acquired presence, could shake him from his prolonged routes and indulgent, however astringent, habits.

Into all that gold. Its gilt brushing off onto dark creating an ikon he held. The harbor of Byzantium. Reaching toward Shay as his lips brush her sleeves . . . the neckline of her dress rippling with explanations and the savors bizarre and antique; moving his mouth across her body with its delicate fakeries and authenticities, interpreting that arch to reach the dome where his shaft in the really spectacular soar might sojourn.

What else am I doing at Shay's? Am I following her "line" as once I followed in the wake of Madame d'Haussonville? There is an order to my indulgences. As once I followed the woman in the painting so now I reach the woman who is painting. The blue dress of Ingres. The blue Mosque of Shay.

As one writer sketches a pattern and traces this pattern into his book, as Turkey is followed by Iran, or the Appalachians followed by the Ozarks, or the Ferrari followed by a cab, or stone into chimney multiplied by one thousand. The mind jangles its chains.

Dark the silent partner.

Amber Shay. Rosy Miriam, myths with the golden hair.

Thanks a lot for your savagery, I said.

Wisdom.

Yes, and it showed in the shade.

That was only idle breathing.

I heard it.

At a different hour, no doubt?

No, on the first beat.

After the rhythm?

No, after the rice.

You don't know many lady painters?

You're the first. After Rosa Bonheur and Angelica Kaufmann.

I don't care for those horses or walls.

You have a very active social life, all the same.

Mostly business.

I hear about you everywhere.

That's business.

Is this pleasure?

Partly. I'd split it right down the middle.

When may I see you again?

Well, I go to Australia on the first.

You never told me you were going away.

Didn't know myself until this morning when my dealer called.

What are you going to do there?

I painted them this picture, right? My dealer calls me up and says the Australians are after you now, right? They wanted a picture so I made them one, right?

When did you paint it?

Yesterday afternoon.

Yesterday afternoon!

Right.

* * *

The luxury of fantasies. Amber Shay off to the land of kangeroos. And fabled Byzantium?

100

60

After that encounter with Shay for whom I had such sympathy and from whom I expected so much, those expectations ending at Kennedy airport, I began to notice all sorts of things wrong with myself. Not ethically, that is morally, but physically. I had trouble drawing a breath. My ears hummed. Then they filled with a mysterious darkness composed of thuds. I "felt" a sore throat. And worst of all when I was exercising with Dark a dizziness assailed me. I couldn't decide whether it was pure vertigo, in which case I would have the notion that I was going to topple over, on the brink, that is, or if my head was pirouetting in circles. These symptoms aggravated my usual sensitivity so much that I was ready to consult either a physician or a psychiatrist. I had one of my worst attacks when crossing Park Avenue. I got stuck in the middle island, absolutely terrified to venture to the other side of the street, so dizzy had I become. Even watching the tugboats ply the East River which before had been a lulling sight, the sweet rhythm of a boat filled with garbage or worse had added a little tempo to my day, now I was afraid to look out the window as the harbor lay either invisible or blurred before me. I could not see my little red or green boats! Well perhaps I could see them, but not so clearly as before.

"Hypochondria resulting from hemorrhoids." This had been the doctor's diagnosis of Gogol's illness which finally finished him off.

I read that yesterday to my horror. "Vevey. 1836." Today they would reverse the diagnosis. And probably finish me off.

I went to the doctor.

He told me I was in fine shape, but that I should be careful of my elimination.

Elimination! I who spent every day adding to and taking from my investment in Dark. I who threw so many of my forces into the struggle of balancing. I who was in the midst of a lifelong game of

bargaining. What the hell was he talking about? It was the month for addition, not the month of subtraction.

It's perfectly true there were many things in my life I would like to eliminate. Australia would head the list. And a few memories. More than a few. Also the difficulty I have in choosing between the present, past and imperfect tenses. This latter is becoming a real bother. I should eliminate it before it goes any further and I should stay in the subjunctive which is really more accurate to my composition. But there is my balance, and I've no sooner got rid of the original than I've added a facsimile. The doctor may be on to something after all.

But to die! Unnecessarily as did Gogol in the home of one of the most civilized and wealthy men in Russia, treated, or rather starved, by the best physicians in the city—vomited and purged and bled to death. One speculates as to who was mad. The doctors or Gogol? I sit wondering if the medical profession has progressed. What if it hasn't? It is no consolation for Miriam to say, "For God's sake, that was in Russia and in the nineteenth century!" She is too kind to remind me that I am not Gogol.

SCIENCE REPORTS

Jan 9, 1975

A new U.S. South Pole Station inaugurated today. It replaces the 1956 station already crushed under ice. The flow of the ice will carry the station over the Pole in a few years. This personnel works in the world's lowest temperature.

Jan 10, 1975

Sudden hearing loss after scuba diving. Place the patient into recompression chamber and send to original depth. Then decompress. "Release of air bubbles within ear may be cause of sudden loss of hearing in these cases," says Dr. Pang of Hawaii.

61

I was still haunted by the malaise of not being me, of a body incorporated in a cloud . . .

While out strolling I saw:

Jowie Kanovitz in his Mack the Knife suit

Mack the Knife

Lying on the sidewalk an advertisement in full color for steak knives. I arranged these events in an order symbolic. They would appear to be, if followed in a direct course, without any ifs or buts, a narrow logical route toward cutting my throat. But here metaphor intervened. By suffering this malaise I was in effect cutting my throat in society.

The small efforts, the earnest advances, the puddings scraped of cream, all caused me considerable physical exhaustion. Even putting a stamp on a letter required a decision I was momentarily incapable of. To retire into my metaphor, it was as if I lay on the lawn under the lawn mower. Or as if I heard Albert Camus saying, "William Faulkner is the greatest writer in the world." I experienced a shattering in my skull, a breaking of barriers. Between me and the words chosen for me by my speech stretched a length of time as expressive as grave stones. As in a certain theatre, the effects were heightened. My voice became hoarse at unexpected intervals.

Thus I began to believe that another tribe had taken possession of the territory circumscribed by my body. We celebrated different holidays. The weather varied accordingly. That is, it rained in areas and the sun shone in another spot. Fear alternated with indifference. Pleasure with melancholy. Nowhere, however, did I experience the whitened intensity which once introduced its cool raging heat; rather a gentleness settled over the territory like a fog. There were hours in which I waited for the fog to lift and when it did the only appreciation given me was relief. And the convalescence was short, before the next stabs.

For these shifting sands or tides two pills were recommended. Both were yellow. They were supposed to work under the tightest frames of friendship. With these two guards at my gates I was promised an easy sojourn through the mountains of my life. Thus if one stumbled the other was there to pick him up. My duty was not to forget their names or their needs, to allow them to enter my system at specified times of the day. The I who suffered was given the prerogative of the temple god to absorb its visitors, priests, missionaries. When I complained about this burden on my conscience I was told to forget my conscience; it had caused all the trouble in the first place.

Even now I am using words which Dark will tell me to replace with bandages.

Confessing my disequilibrium to Eustace Worthal he told me at one time he had suffered from similar symptoms and had found a workable solution. The idea was to go around on roller skates so "one could skim over the truth lightly." Thus, "even stubborn surfaces will relent."

Eustace was engaged to Kitty Dunkerley whose best friend was Arizona Bundy, related by marriage to Oscar Mewshaw. Petulant, spoiled, she often gave the appearance of having her knees glued together. Her long hair gave her a labyrinthian effect which she did little to earn.

Sitting on the terrace under the bright deceiving light of April I hazarded a few guesses in the direction of their inevitable marriage and I must say the shadows around them rose and fell with becoming ardor. There was a gallant patch of sunlight into which they stepped. Then clouds skimmed the further reaches of the terrace and the iron railings turned chill and resistant. I seriously regretted the lunch I had eaten of canned tamales—selected in the hopes that a touch of Texana, a corn husk of Texas beef, a shard from the border, might bring a little poncho style to my day. Texas had always been a threat and I should have known better. Driving from Los Angeles to Albuquerque, then crossing the panhandle at Amarillo, unfailingly brought disaster with its sleet and wind storms. I had never penetrated the golden reaches of oildom, but even there regret would await me for the spent fossils hidden for those æons below the surface over which one should ride.

OCCIDENTAL PETROLEUM CORPORATION
ANNUAL REPORT
FOR THE YEAR 1974

The Permian Corporation

1974 was another record year for Occidental's domestic crude oil marketing and transportation subsidiary, the Permian Corporation, which recorded the highest total sales revenues and net profits for any like period in the company's history. Sales totaled $1.45 billion compared with $752 million in 1973.

Permian's increase in total sales is principally attributable to higher crude oil sales, most of which were consummated outside the U.S. and from increased oil well service work. Total daily volumes of both domestic and foreign crude oil handled were about the same for each year—503,000 barrels per day in 1974 and 502,000 barrels per day in 1973.

Occidental Oil Shale, Inc.

Testing and evaluation is continuing on Occidental's soil shale property in the Piceance basin of western Colorado. The Occidental process . . . involves mining underground rooms, expanding the shale into the mined-out area with conventional explosives and retorting the fractured shale underground to release the shale oil which is pumped to the surface . . . Since mining operations are greatly reduced and no handling or disposal of the spent shale is necessary, the process can be operated by a small labor force, with relatively little disturbance to the environment.

The Occidental Petroleum Corporation Annual Report for the year 1975 reversed its 1974 optimistic figures with a tremendous

105

loss in revenue. This loss was countered with an elaborate accompanying brochure of photographs of the successful alarums and excursions on the battlefield of Art by the Board Chairman or whatever, Mr. Arthur Hammer. Both Russia and South America had been subjected to his battering and the brochure sought to prove that if economics had failed us, the high moral rewards of the Arts were our gain. There was the obvious moral lesson to be learned, so I supposed, the cultural benefits far outweighing the mere . . .

But to continue. One of the truly nuisance symptoms was that parts of speech would never attach themselves in their proper places. Nouns and verbs would float anywhere and adjectives often refused to take any position whatsoever. I once started to tell Eustace that I found Kitty "amiable." But I could not locate that word *amiable*, search for it as I did under cover of a cough. This might be because I was lying. Yet lies don't prevent one's vocabulary from its performance. Or do they? I suffered these lapses especially with people I didn't know very well, the dinner partner to my right. Words would hover over their unacknowledged heads and then disappear. And yet my conversations with myself, such as the one on the terrace in the chancy light, was quite strict in its use of grammar. It was the light, itself, and then the alternate warmth and chill of April, the promises and denials, the sudden hornet buzzing against my unspoken clauses that would then cause me to become a little erratic.

And as converse with people became difficult and nearly impossible to track, so Dark loomed like a great healing force. I began to rely on its protuberances, crevices and commanding sites. Who knows, I might assume the role of the-one-who-is-preoccupied? Others had taken shelter there before me. Yet it was a game with consequences not altogether pleasant. I truly did not wish to suffer exile like Swift. I did not want to be relegated to an island, no matter how emerald. I did not want to shake my bones in a deanery. And if worst came to worst I definitely did not want to go mad and suffer that idleness madness imposes.

> Active as he was, Swift was always under the shadow of his puzzling sickness . . . He was, we shall find, even more highly strung than the common neurotic, but never *insane* . . .

What chills that fetches forth, despite the slur against the "common neurotic." This diagnosis was observed of one of the finest minds of his day. "A giant" as he would be called in our Lilliput. I forced myself to read further with that kind of urgency that makes one tempt the devil and sure enough was rewarded with a description of the desecration of Swift's tomb and the opening of his skull. Not once but twice! After ninety years.

> Where is the *me* in all this?
> It's only a story, dear.
> But did it really happen?
> Don't ask foolish questions, dear. Now turn out the light and
> go to sleep.

Once one begins the attempt to penetrate the citadel, even if it is only pulling apart the conch shells of its walls, as in the Spanish fortress of St. Augustine—at the fringes, as it were, of madness—one comes across all sorts of loose information.

Eric Idle wrote about Lord Shaftesbury's Diary:

> It was symptomatic of this narrowness of intellect and imagi-
> nation that he first became involved in humanitarian work,
> almost, as if it were by accident.

Florence Nightingale has this to add, and it is said not without some truth: "Lord Shaftesbury would have been in a lunatic asylum if he had not devoted himself to reforming lunatic asylums."

"Letters Mingle Souls" perched on a stamp arrived in the mail. Who is there to say that John Donne was either wrong or mad, or indeed the U.S. postoffice.

I bought you those stamps, especially. Miriam looked hurt.

I don't need to be told what my letters do.

And I suppose you don't want to *mingle*, either.

An odd word. *Mingle*. How does this sound: "Letters *entwine* cat's feet."

Are you mad?

62

I am confined to my home by restrictions self-inflicted. "House Arrest."

The house with its heavy consciousness.

All the rooms are full.

The furniture unable to breathe. Tables, chairs, sofas, rub against each other. Seeking air. Space in which to breathe.

He felt not claustrophobia, something more tiresome, urban, the tension of a subway. His living room.

An Ozu movie. Where the camera remains to show us the room after the inhabitants have left it. The room still full, burdened with presences.

He could not write in his house. Preceding him, antedating him were the action, drama, rehearsals in the chapters called Life. The room ached with selfishness.

He wondered. Is a novel made up of partitions, screens, as in a Japanese home in an Ozu movie? Do we put up these partitions and then take them down? Is the continual movement of these partitions the unfolding of a plot?

Usefulness of screens.

A place to hide behind. Assuming a husband's surname. The gentle wife drowses behind this name she has assumed legally. The angry wife fumes behind it. Sends up funnels of angry smoke behind the screen of her husband's name.

The husband, carrying his name, the only one he will be given, into the marketplace, to the cemetery. His former wife has a new name. She sets up the screen and smiles behind it. She strips the screen of its ornament. She tears a gash in it and through the gash stretches her angry head. She is ready for another partition. In time, if she can find it, she will put up another screen.

He opened the window. Calm air entered, stretching only its toes.

He practised breathing air. It was difficult, because the more he

wanted to breathe the more he halted the automatic process of breathing. He threw open the window. Air rushed in. He tried to catch it, but it ran past him. He began to breathe with his mouth open. The dizziness that had been allayed by his concentration on air now assailed him. He knew what is meant by "fast, jerky breaths."

His "usefulness" evidently did not contain the art of breathing.

He went to the icebox and opened it. He put his head in it, into the cold dead air. Breathing into his fingertips the picked out an orange. Still with his head in the icebox he began to peel it. He became intent on the art of peeling an orange, carefully, all in one continual circular peel, unbroken. He remembered then he was breathing.

The thick undercoating of the rind contained cholin, or was it folic acid? He knew it was good for him. He must accept the sources that would "improve" him. Therefore he bit into the rind. But wasn't the rind bad for tooth enamel?

He went into the bathroom and took down his toothbrush. But first he breathed into the mirror. Misting it. That was good. Didn't they always hold a mirror over the mouth to determine if the corpse was alive?

After he had brushed his teeth and congratulated himself upon his activity and his mimicry of the act of living, he went back to the window. If he placed a mirror outside the window at the proper angle then he could watch the street. Couldn't he? Wasn't that what they did in Holland, in Amsterdam outside the window so the good wife could learn what the street was doing?

If he thought about Dutch painting hard enough it was possible a peacefulness might radiate from the painting with its cool tiles and scrubbed kitchens, its sunlight brooding on plump arms, and he might find there a simple clue with all extravagancies removed, so that his own pattern might follow that of the Dutch tiles. He would become vigorous and pure.

"Simplify. Only simplify."

63

Eustace came to see me one Saturday of the following weeks. He handed me a piece of paper on which was typed:

You old Fool, come out of it, get up and do something useful.
 Kung

It was the only thing I could find to bring you, he said.

It was such a valuable bit of advice he wished to share it with me in case I hadn't been reading Ezra Pound. Which in fact I had.

I read it in the morning light which is stronger, of course. At the time it seemed most valuable. Most valuable as a statement. Now that I reread it in the evening dusk, I see that the first three words are really the most important.

64

At the same time Miriam had been talking with Clarissa Harlowe, long engaged to a soccer player.

Morgan, she went on, talking about me. He found this knife.

He lies with his back against the wall. He lays the knife beside him. He is like a child who has memorized in class a poem and in his fear of forgetting its lines repeats them all day long. Then of course there comes the time when he has said those lines over so many times he begins to skip, he loses his place and falters.

He has a compulsiveness that is disturbing.

Wanting the knife to shine.

Wanting the knife to be protective yet useless.

He looks at it in the mirror.

He slips it into his briefcase?

I can feel it there between us. Its insinuation. Its refusal to let me trespass.

Almost as bad as Dark. Only a newer thing.

What do you suppose he is afraid of?

He tells me he needs it for the distance.

Does he mean how far he has to go?

Or does he mean the knife is useful to keep things at a distance.

If he meant that he would have used the preposition *at*. When he wishes he can be very ambiguous.

He likes it to be in open places when he goes to it.

As we talk I began to catch the outline of what the knife is all about.

Fear, I should hazard.

65

By the end of the week I had relinquished all hold on the knife. It might just as well have never existed for all I cared.

As I looked around me so many other subjects presented themselves that I would find it a foolishness to devote so much of my time to the knife, which in reality represented only an association. Rather, the day I had found it was covered with associations of the sharpest. Now I wished to give the knife the slip.

There were other summons. To step out of the scene. To leave the apartment and go to the park. A going out was necessary here. To go somewhere one could listen. Out of the hollow of one's head.

(Harry Mathews once remarked that he liked to write his books in Amsterdam, or Stockholm, because he did not have to listen to conversations in public places, the speech being incomprehensible. Ergo not interfering with his own thought processes.)

Giving a final little pat to Dark as I prepared to go out I heard the doorbell ring. It was the exterminator. Come to disturb, yea to wipe out the kingdom of cockroaches who share my situation. To be honest I had become almost fond of the eager little fellers and their fecund mothers. From birth initiated into the savagery of chemical warfare they yet maintained their footing with a cunning and courage one could only admire. But enough of this humanitarianism, they obviously had no similar regard for me. I let the exterminator wreak his vengeance. Both of us knew that within a few weeks the survivors would have multiplied; the balance of power would again be readjusted.

(Another urban scene requiring my "relating" to.)

Once again out on the street pushed east and west by the unflagging noise of machinery, I felt a desperate need to observe slow moving objects. It was the "intervals" I wished to celebrate. As any one knows there are few intervals in New York City. They must be carefully uncovered, their rhythms caught at the moment of surrender.

Stop and Go lights bring up a small harvest. The difficulty is that after everyone has been halted in his tracks there always comes a straggler speeding to the light, disrupting the evanescence of the struggle, the interval between the pending movement and the stop.

From my terrace I notice the frequent lulls in the traffic of the sky. Cloudy days and fog produce concertos of intervals, like those of John Cage.

Snow, as I must have pointed out, is perhaps the ne plus ultra. Simply having the noise dimmed creates a false watt as the tires crunch silently through the snow carpeted streets. One may close one's eyes and relish the interval, knowing that sometimes nearly a minute will pass before the scene again becomes blurred with other categories of movement.

> Zum Augenblicke durft' ich sagen:
> Verweile doch, du bist so schön!
>
> GOETHE: *Faust*
>
> (And to the instant I could say
> Please linger on, you are so beautiful)

Today I stepped lively down the street, a *fille de joie* in search of an interval. I was immediately rewarded with one at the greengrocer's when in the act of lifting a tomato onto a scale he stopped midway, his fat hand halted by a question from the customer. The ripe tomato poised midway in vegetable air was the gesture I was seeking. This sortie was beginning with an intimacy I hoped to graduate into largeness and depth. Everything depended on chance. Following that, alertness and patience.

Hearing and adjusting to what Eric Rhodes calls, "the tick-tock of transience."

Writing of the films of the master filmmaker Ozu, Rhodes says:

> It is of the essence of Ozu's style that he communicates a feeling for the passing moment, a transience which can contain within it an awareness of nothingness and death and a simple sense of contentment.

113

The branch of that plane tree on Sixty-third street, slowly catching its breath, at intervals of stillness.

The second one begins to put down the telephone receiver, a voice calls hurriedly from across the space, Wait!

Losing sight of the freighter as it cruises under the bridge and rounds the bed; its reappearance.

Lighting the oven.

Evening light into darkness.

I return a book to the library. Across the stacks of cards the librarian reaches out her hand, books lie still and expectant, a card falls slowly out of a book and onto the books that wait on the table.

In conversation with Mewshaw I hesitate before priming forth the next syllable while he readies his nervous cough.

Samples, mere samples. Between the negative *mere* and the positive *sample* what an interval!

> I look on the stops not as logical Symbols, but rather as dramatic *directions* representing the process of Thinking and Speaking conjointly[the speaker] pauses—then the activity of the mind, generating upon its generations, starts anew—& the pause is not, for which I am contending, at all *retrospective*, but always *prospective*—that is, the pause is not affected by what actually follows, but by what anterior to it was forseen as following—

> COLERIDGE: *Notebook*
> (vol. 3, p. 3504)

I am indebted to Mr. Charles Rosen for pointing out this acclaim of the pause. Mr. Rosen is a pianist and author of *The Classical Style: Haydn, Mozart, Beethoven*.

It may seem that I am taking those pauses, those lapses in a lapse, as if they were part of an intimate, even sentimental game. But I mean what I have said. Life affects me this way. I need the game, as well as the joke being played on me.

Coleridge recognized the use of the interval turned into a fragment of time, and as it has been pointed out, he signalled this usage with the dash. The dash more than any other form of punctuation expresses the indefinite pause between one thought

and another. This space between dashes is a fragment of the composition, the movement before the vegetable reached its scale. The dash anticipated its explosion on the other side of the phrase.

Goodbye—precious intervals—

> Adieu les larges clairs de lune sur les gazons verts et les nuit bleues toutes mouchetées d'étoiles . . .
>
> FLAUBERT: *Correspondence*

66

An interlude . . .

Courtly Spring is here. Aquitaine arriving in the North. Oscar Mewshaw and I are planning our Crusade. We hope to combine flowers with ice.

What appears to be insurmountable, after we have laid our map on the table, is the charting of our priorities: (luggage), discriminations (poundage), mobility (performance), additions (extra countries), resolutions (languages), advertisements (visas), losses (which we leave behind), prejudices (1st or 2nd or 3rd class). (Whether to go or not.)

Jousts and tournaments were anticipated. The overland route to Aix and then from Marseille by sea to—Tunis? We unfurl our banners.

Mewshaw displays an adept and intriguing horsemanship, thus encouraging my gamesmanship. Ruins. I insist on a few, combined with ampitheatres of the mid-eleventh century variety. Mewshaw holds out bravely for Roman establishments which as I point out would lead us astray in Turkey or Lebanon.

It is a contest of centurions. I honestly believe it foolish of us to retreat further than the 10th century; Mewshaw considers this era an ending, piling up value points in his recital of the priorities of earlier ruins.

We are caught in the gauntlet of "ruins and civilizations."

Unheeding we parry on "untying the knots of remote cultures."

I attempt to divert this to "less remote and more advanced."

In one clever parry Mewshaw catches me unaware with "Myth, Nature, and Man."

Unhorsed now, from my disadvantage I try to conciliate with "From Pagan to Medieval."

Mewshaw shakes his helmeted curls.

The battle—in what is here only a shortened version—dissolves and the centurions retire to their chambers.

In my unsettled state I attempt a little night reading from *Lyrics of the Middle Ages*. Guillem IX, Count of Poitou begins his poem with this drowsy line: "*I'll write a poem then sink to dreams*" . . .

The month continues to be distracting. A period of quarrels, misunderstandings. Miriam and I at loggerheads. Parts of days devoted to rain, other halfs to sun.

Just as I was readying myself to suggest that Mewshaw and I board the *Pushkin* at Liverpool for St. Petersburg—secretly gathering a small pile of Russian books in translation—congratulating myself on indeed having found the path from flower to ice, I developed tooth trouble.

At least it's real, said Miriam.

That is to me the most absurd—I searched for that word with the shape of a pear—*jejeune* remark anyone can make. And one that can *ricochet*, I might add.

I was getting bored with that old trip.

Alas, she was right. The trip was growing old. It had been clambered over, caressed, soaked, thrown up in the air, and now it was deposited weary at our feet. Unclaimed, soiled and corrupt with the miniatures of our *folly*.

A few days later I received a card from Mewshaw on which was sketched the itinerary of Lucius Aupelius, his passage from the Roman colony of Madaura in Numidia where he was born in 124 A.D. (this date carefully circled by Mewshaw), to Athens where he had completed his education. The Golden Ass!

Later Mewshaw confessed that he based his dislike of the Middle Ages on the confusion regarding the Virgin birth, this leading to the corruption of the clergy. He explained it was the Catholic Church that kept him off the Medieval turf, as well it might. He, Mewshaw, having been raised a Christian Scientist.

67

Despite my disappointment at the abandonment of my journey, I began to notice delicate hues covering people's faces. Rosy-fingered. Now armchair cruises filled our evenings lit with this fresh madder and fading into clear cobalt as evening passed into night. The night munched at by stars.

Now I experienced the reflexes of the traveller. Delight at my safe return, homesickness alleviated, gestures and ellipses viewed with the exhilaration of one who has had his eyeballs rinsed. Hyperbole abounded. I was once again in the embrace of my city.

Mewshaw who had gone off on his own wrote letters about dogs and bowling alleys, tennis courts and herring. The dogs he had seen in Siena; the bowling alleys in Florence; the tennis courts in Rome; the herrings were Zurich. Jogging along his tame route I envied him only his extraordinary visions, wondering what he would make of the Day Line boat that tripped the shores of Manhattan.

The stars continued their munching.

68

Time, said Tony Smith, works for you.

And so doth Work, said Eustace Worthal, ringing down the curtain in Berg-like tones, part strength, part pathos.

The curtain fell as the blue bus turned the corner leaving the theatre bare. The audience seated on rough benches scraped the cement with their shoes and hied to softer sidewalks anon.

Berg changes to Shostakovitch. The Cyrillic alphabet just out, crosses in front of, enters the space the bus vacated. The poem laughs back and forth and comes the caw-like repetition. Strength comes to blows with Joy. The violins fly from steppe to steppe and in the Caucasus valleys stones skim and fall. A stocky tremolo with light flashing on the flung scabbards. Numbers work for you. Desire trudging beyond the golden mean.

He kept picking up his pen, like a painter's brush, laying it down, as a dentist places his tools on the tray. Selects another and begins his digging. He was digging a trench around Dark. Dark was in the center. Circling around him were the trenches. The earthworks. The turf walls dropping sharply down to the ditch. Another earthwork. Dark mewling and puking in the ditch. Scrambling up.

He wanted Dark to have a carefully warranted history. He wanted Dark to peer far far back into the past. Beyond the living settlers to the long dead. Dark must have a beginning.

If it were possible to ride that blue bus on its circuit without losing his grasp as it passed his corner. If he could begin where the route began and continue to its end. With no flash-bys, no escapes. The route was undeviating. Yet the bus passed beyond his window following the route he knew and could not see. There were ellipses in lives, the same as Dark's appearances and departures. As one loses one's sense of humor. Or time itself is lost. There is the meaning. Time goes on, visits another place, yet where it occupied is that still visible?

What is it that works?

The water bubble lies on the lemon leaf plotting its assimilation into the tree. It rolls ever nearer the leaf's edge. The terracotta basin waits. Seized with a temporal anxiety.

Seized with a temporal anxiety I shift from foot to foot. The weight more cautious on the right where the old scar still sends forth its signals: more grain on the left, more leaf on the right.

Time, said Tony Smith, works for you.

The sense of becoming disturbingly real to oneself, that point where the interior conversations begin, like daylight picking its way over a bridge, over there to the further shore to shine its brightest. The difficult shell halved and the sparse interior looked into, a voice appearing and disappearing with the light that fell on one's single self. Difficult to arrange this monodony. A necessity, the act of discovering where the self starts, hears itself, and repeats the instructions. Where dreams tumble these directions, pile them one on top the other until there is the night harvest, and afterwards, the search under the haystack for the heir.

With joy, of course, Time permitting. A succulent future begins to shape, thrown from the night blossom. Evidences are sharpened: yet there at the furrow of the wound new skin thickens healthily.

We walk. Time bows us leisurely, opening up the lanes, breaking the water jugs, sealing the wrathful places. The incompetent acres are plowed. Wisdom lurks at corners. The bodily graces are leased, each grace incorporated, all in rhythm moves the line.

So arrived the month of May. On schedule, someone remarked.

It was the distinguished sweetness of the mornings, however ripe, more like July mornings, that made him wish to postpone his tasks. The season was rushing, the air throwing welts like petals falling and he begam to wait until the day would reach its true dignity, like a child growing taller, before it can assume the tones of an adult, before searching out and attaching itself to its subjects.

Then he would seat himself in the round chair, adjust a pillow and pull the strings that brought that back-glancing undercover figure forward. From there he could sort and label the tags he wished to place on Dark. Then his fingers would reach relaxedly toward the typewriter keys and he would transfer onto the carefully proportioned cards his notations, his gifts to Dark.

69

Yet you did hear about it—didn't you?

I heard the news, but I wasn't paying any attention.

Do you mean that you weren't startled?

Scared out of my wits? No. Whatever they were saying evidently seemed to me inaudible.

I should think that however remote the news was at least your sensibilities—I mean—your feelings as a man . . .

I hadn't understood that I was receiving a message

Of course if it had been an advertisement or something as banal as introducing a new soap I would understand your "turning off" but from the very first words

I tell you it is possible I didn't hear the first words

Yet everyone else did

Everyone else isn't me

Ah. So that's your argument

I am not defending myself

You're certainly not explaining yourself

I hadn't realized there was any necessity for doing so

Precisely. And from there on out we disagree

Why should I disagree with you when you have only to open your lips

How can I be reassured that after I have opened my lips my words won't fall on closed ears

They never do

Maybe not for you but there are others who cease to listen. I can tell when I have gone just a little bit further into the sentence that I have lost my audience

You are much too sensitive, or too accurate

Yet to go back to what we were saying even if you didn't listen to the beginning of the words at least the brutality of the event might have struck you

The event wasn't what you call brutal for me for the simple reason I hadn't paid any attention to it

When over three thousand people are involved and you mean to tell me you didn't pay any attention

Have you noticed how you have used the word "pay"? We "spend" words and "pay" attention. Did you know the Victorians called sexual emission "spending."

You're very clever but you're not going to divert me

I'm not trying to divert you I am only explaining to you the words, the subjects, which cause my attention

You must be living in a private world entirely

Doesn't everyone.

Oh of course if you put it that way, but most people try at one point or other to get outside themselves, they even want to become involved with others

With common topics.

Things they might have in common with other people

Things, common, other. You aren't making yourself very clear to me

I'm only speaking realistically. Choose your own words

Exactly

What I'm trying to say is there's a sympathy we sometimes feel for others for what they suffer for what the world endures

I don't deny your argument I only say that I did not *hear* the news

Everyone did. It was broadcast all day long

In other words it is *impossible* for me not to have heard the news

Nearly

I didn't

70

Why do you call all the boats out there in the harbor, freighters?

It was a question I proposed to myself. Recognizing a cargo ship when I saw one and a flat boat when I saw one and a sail boat also, I still insisted on referring to the "freighters out there in the harbor." Could it be that I assumed the river was only meant for cargo and that selecting a heavy word such as freighter I could pile on it my knowledge of what happened on the river.

True I considered the East River as a body of water to which tasks were assigned, sturdy ones, causing us to speak of this river as cargo-laden. When empty, however, the river had a relaxed look such as a worker might put on when he scuffed off his shoes or laid his head down on his desk, or his tools rested on a factory ledge. I cared extremely for that river; it had nursed me through many a bad hour, yet I labelled it as "transitive," capable of taking an object. Although a minor body of water, that is in scope, at the same time it was worldly, commercial. It had majored in Commerce, whereas the Hudson River was in the Humanities.

I had written somewhere about the Hudson: "*Barges on the river carry apples wrapped in bale.*" Romantic pomegranates down to Hades. "Lordly," the Hudson had been called. That river caused me trouble as I became entangled in its history. I wished to ferret out the secret under the ice floes, sound my hunting horn upon the cliffs sloping into the water's edge. Sunsets! Chrysanthemum floats, Japanese fireworks, insomnia . . . torment. Poetry. I would never learn that river's lesson. It was best to abscond gracefully, leaping over a floating bough, or poisoned shad.

Now I am ruminiscing as someone said stumbling over reminisce, it was Tony Stubbing who said that, not meaning to coin a word we all heard it and laughed and slipped it into our lexicons. Ruminisce.

Where had that frozen food come from? Last night's dinner. Frozen fried chicken and cotton—no, not cotton, that was a

cliché—the potatoes were powder, there was a sweet sort of running apple called a tart, and some grainy peas and carrots. Who had ordered that food? And the night before, frozen chicken pies with that false sauce, a little beige colored to give it a culinary hue, and for lunch the spinach soufflé made of flour and green graininess. Surely not Miriam? Or had she done this against the days of my illness, my feebleness about going outside, a little something in the freezer . . .

Had she suspected that I was anticipating my own arrival in a freezer? Just slide the door out. We had read these scenes in our pursuit of the victim followed by the detective. How had she known that my ultimate fear was my blunders would lead me to that tray?

"All though history," wrote Trotsky, "the mind limps after reality." What if I had attempted to get ahead of this final reality, had taken a few leaps and jumped a few tracks? Had Miriam in her wisdom forseen this and ordered those phantoms of nutrition, breast and leg chemically conjoined? Those pastiches to be consumed as a last supper?

I began to hallucinate a little. Hallucinate? Funny that word. The attachment young poets had to it. They walked around saying quite openly that they had been "hallucinating" all day. Part of the drug culture. Availing nineteenth century secrets to the general public. Drug culture was a new phrase, also. Value judgements. Making value judgements. That was a stunner. Why don't they say I was "illuminating all day"? The trick was to turn nouns into verbs and adjectives into adverbs. Like sex changes. You could do it with a loaf of bread. With total accuracy, "I was loafing all day."

Had Miriam somehow got wind of Shay? Or should it be Miriam got the wind up about Shay? Something confiding about those frozen dinners once you took them out of the grocery store.

She would have returned from lunch. The office would seem stuffy after her glorious two hours away, and lonely. Joining the crowds, walking against the surge, trailing her hand in the pond, sipping from the fountain, guessing through the pillaged air that summer lay above it. The carafe of wine . . . reading . . . talking . . . today it would be in French, her client from Paris. The two of them ennobling the midtown scenes with their graces and smiles.

Stopping to look in a window . . . the quick goodbye kiss . . . a pleasant arrangement over "rights" to be savored the first few minutes in the office . . . before the static air and common sense reached her.

Those frozen dinners. Were they worthy of an intrusion?

Now you listen to me. I tell you I did not buy them.

Who? Well there's yourself for one and the cleaning woman for another and isn't there always an old aunt lurking around?

I'm not angry. I don't know why you are accusing me of this . . .

I suppose you think and after all these years that I'm the sort of person who . . .

It never even entered my mind . . .

Why are you so suspicious . . . ?

I wouldn't think of entertaining such a suggestion . . .

You're beginning to sound as if you're the guilty one not I . . .

Did you eat them . . .

She probably pities you . . .

Why . . .

People always have a little pity for bachelors . . .

However you consider yourself other people think of you as . . .

The subject hardly . . .

You began this . . .

71

Those two wretched months of January and February . . . after the departure of Shay . . . my inelasticity and nightmares . . . the forbidden fruit snatched from me and imported to Australia where the natives no doubt were enjoying it under their sunny summer skies surfing madly through their wretched waves . . . employing the tactics of colonists and aborigines . . . whereas we our chains earlier severed from the mother countries went foraging on a wasted landscape . . . every day an ice age threat from the melting Arctic . . . it was no wonder I shed hot tears of remorse and succumbed to attacks of dizziness, the vertigo of an endangered herd . . . as Eustace had pointed out it was at times the only civilized way to behave . . .

If he could only grasp what was visible and put it there beside the boxing invisible . . . there where the pain starts to sting . . . where it throws out its hands and feints . . . where the grasping toes begin to unclench . . . where the rhythm of the interior meets that echo coming from the station . . . if he could do all this without stopping and starting, eating too much cottage cheese and not even wanting it . . . not even with the cold fruits added and a fresher taste placed there in his mouth . . . without overstuffing and forcing things . . . there he might find himself a nice resting place . . . a stone on the mile and read it with so many quarters to go until he had the final sum . . . he had finished the race and could spend the evening at home with everything in its place and breathing nicely, too . . . would this happen?

Shay might do for a starter. Down there stuffing pound notes with leaping kangaroos on them into his letters, not even a good portrait of the Queen . . . telling him how she liked the wave clippers and the new opera house . . . he had better begin with her . . . commence cleaning the house . . . out with the memories of her pressures and the light bulbs they had played forcing one another's attention.

Let her marry the tennis players. A novelty and good for the notoriety. "You know the painter who's married to the tennis players?"

He had enjoyed his excursion with Shay. His sailing up the Golden Horn. Now that was finished. She had fallen on the debit side of the ledger, so crowded already. He wasn't being cruel, "merely realistic." He could not afford the expense of her absence. Her room was too crowded with mirrors in which his reflection gazed back. He needed windows and doorways.

72

Euphoria is a feeling that is inappropriate to
one's life station.

WEBSTER'S DICTIONARY

So I begin to float on "sooty pinions" of surmise. That Miriam and
I might continue in a more peaceable kingdom.

That the ragged edges of Dark would be straightened and
Capital letters added to its chapters; that Dark would find a
privileged position in thinking—I wondered about that—people's
homes.

I could see Miriam quiet in her corner. Myself, legs stretched to
the friendly fire, sunken deep in my leather chair and Dark at
home on the table that graced the Hall. It was one of my Manor
House Reveries. And *completely* silent.

Opposed to the Scottish Bracken Reverie. There poised upon
the rocky mountain, silhouetted by the fine rain and shimmering
rainbow, the salmon stream far below, stood the Stag. Warned by
Dark I shouted down the hunter's gun. The stag after one startled
gaze leaped and raced away. I bore with the thunderous oaths
from gamekeeper and stalkers who in rage had ignored the speed
and neatness of my grellocking. Yet at least one more day upon the
scented shrub would the stag graze and keep with his hind. Dark,
the criminal, had scored.

Other consolations claimed approval. Food festivals, the arrival
of *Craft Horizons* with illustrations of folk crafts and gold painted
dancers in a Tokyo nightclub, weight loss, Inspector Ghote, new
rose geranium leaves, a postcard from Iceland, three small boxes.
These joys were balanced by a sense of jeopardy that often
waylaid the delights tripping merrily toward me. To protect
myself I developed a wrist power, a gangling gait, an orneriness
that looked speckled with horns.

Like Christian I plodded toward Euphoria.

Each day proving: "revolutions beginning with euphoria cannot remain mere words and noisy celebrations."

73

About another journey.

The Venetian Postcards. Piazza San Marco grazed with silk. The poled gentry solitary and luminous bowing to the courtly few in, for once, an empty square. Guardi, Canoletto, Ippolito Caffi, Michele Marieschi, Gaspar Van Wittel. *Le Migliori Cartoline Illustrate.*

Mewed there. Trellised to the wall. Shoes bouncing on stone. Shouts. Captured weather limping to the faded walls. The Biennale. Browsing in gardens tamed by pictures. Dialect and inky squid.

"I am leaving for Pisa. I shall miss you, yet it is best, my adored Contessa. I must see my little daughter."

Cicebo. In flagrante. We "open in Venice."

On to Verona.

Visiting Violet Wishing, a permanent expatriate. Later when we had admired the architecture to whose beauty we were nearly immune—as after years of exposure we refuse to admit our home town can be guilty of monstrous self-inflicted grotesqueries— there we sat in the twilight on her little balcony with its pots of violets, anemones, hyacinth—which reminds me that in the family of Mme Giscard d'Estaing the girls were given flower names, hers being Aynemone—we sipped and talked of English things.

Violet laughed. She told us that once when lecturing on Shakespeare, Arthur Quiller-Couch had remarked, "But then there were no gentlemen in Verona."

Dear Violet Wishing. The academic mind at its most . . . we savored it. I tossed a morsel or two to Dark off in the recesses of the gallerias. Later in the winter (Winter's Tale) we would crack our teeth on these chestnuts.

She kept a tidy house, mostly. There were interesting exceptions. Strewn and broken objects behind closed doors. Candle drippings on the table cloths. Olive oil on scissors. Tennis balls

inside China jars. Mildew on the ceiling. Yet nothing that might compare with Venetian households.

Never once did she admit a homesickness beyond "these gaudy melon flowers." In her maidenlike feminist way she carried on a small risorgimento of her own.

Now I remember.

There was something in Violet's "style" I would like to add to Miriam.

Note: Pick up a copy of *A Room With a View*.

74

A Step Backward.

Today I came across the letter from Llew warning me about Miriam. "I tell you she is a leech. She is a vampire. She would take my ideas. My ideas and stretch them, tear them into lumps of meaninglessness. She was seizing my methods without understanding their use. They were reduced by her. Thus destroyed. I warn you."

Useless to wish Llew had not expressed himself so uncharitably. Uncharitably! Faith Hope and *Charity*, but the greatest of these is *Charity*. *Charity* entered with the Rheims-Douai Bible. The other translations read Faith Hope and Love. Finding little love in the Kingdom of Man, the King James scholars temporized with *Charity*. Is a pomegranate a love apple?

For what purpose has Llew sent these worms to crawl around my heart? To fatten and multiply? I must send them out early while the dew is on the grass so that they can slide and slither into their earth.

What is the purpose of this message?

Why this week should he remember to install these creatures to feed off my entrails—these days when I question Miriam, just short of accusing her—when already the upper air is disturbed. And she my only witness, as I am her single object. Or she my single judge and I her only witness?

Between two people there exists always this frail pathway where reeds, grasses, weeds must be cut down so the slim shadows of ourselves may come and go without stumbling or suffering in any way hurt.

The taut wires still hum. The bricks lie in place. The armature has no crack. Yet beneath the surface is that ledge upon which mistakes can wrestle, teasing the precipice. Unlike the whispers of brother and sister the risky words must be given no chance to form.

Like the folded wings of a moth placed between two sheets of paper the message hidden between the wings falls to dust if no one shakes the paper and removes the moth.

> *Tender-handed touch a nettle,*
> *And it stings you for your pains,*
> *Grasp it like a man of mettle,*
> *And it soft as silk remains.*
> *So it is with human natures,*
> *Treat them gently, they rebel*
> *But be rough as nutmeg graters,*
> *And the rogues obey you well.*
>
> (AARON HILL)

Am I a man of mettle?

Just now my umbrella fell across the threshold where it had been drying. Concentrated as I was upon my dialogue with Miriam I thought the umbrella was a little dog emerging from the terrace.

Am I indulging in phantasms about Miriam? Do I seek in my criticism of her behaviour proof of my own innocence in my half played game with Shay? (And others.)

Fortunately I haven't broadcast any reprimands to the world. I was probably at fault in discussing his accusations with Llew. But I'm not going to reconstrue that conversation. Of course he claimed he was acting in my interests. He and Miriam had at one time a long association. I had always believed it had brought a mutual satisfaction. Miriam had often confessed that she had "pried" ideas from Llew, made them shape up, flavored the brew. She appreciated his originality together with the difficulties he had in "putting it all together." Also and I can certainly agree with her in this, she had made a most effective audience and sounding board. She created an ambience for him of informality and charm into which he could relax and subsequently labor more.

Llew wears a cloak of many colors.

Living alone in that great barn, his hatchery, there's no telling what resides under his eaves. "What do you see when you turn out the light?" as the Beatles used to sing. Nutmeg graters?

75

How orotund the city voice in the spring rain, Miss Miriam Jones. That thicket of trees filling the backyards of the houses across the street. An orange firescape penetrating the exposed side of the Synagogue whose stained glass windows had formed prayer wheels all the winter long.

How difficult to forget winter's miseries. Dragging the March chains into April. Loops left over for May. Still that piece of chain remaining for June. The fetter I can't let go.

Iced tea is no remedy.

Out there over the bridge . . . the unresisting country . . . a struggle to remain here . . . keeping up the maintenance . . . brushing the straw off one's sleeve.

Plugging in the extra cord for the air-conditioner.

She is standing by the bureau. Combing her hair. This she does thoughtfully, as if to catch up with something, a stray quotation, or even to gain time. She looks into the mirror for the strand that escapes her. That other person who is not in the room. I see her opening a window. The fresh watery air grazes that strand of hair and her hand thrusts it back. Now she looks out the window. At the chimneys. At the wet sidewalk. The empty firescapes. She moves the pot of rose geranium out from the sill so it can gather in the rain. She waits for the telephone to ring. She waits for a voice to release her from the solicitude of an empty room.

Over the telephone she is going to tell me that she is neglected, ill-treated, and then trying out the word, travestied. It comes over in the tinny vibrato she was always able to climb when she wanted to exasperate me. She uses it when she asks, "Have you been reading books again?"

She is about to say something about enemies. With her narrow hands and nails she manages to get in the first wedge. She resists the following strikes as the telephone speech becomes rapid, dense, syllable piling on syllable. She wants to shout. These are

only *words!* She tells me she is going to let those *words* starve.

My laugh surprises me. The laugh took over my person. I even stood outside it and watched its windmill. All we heard over the telephone was its draft.

The reducing grind of a nutmeg grater.

The conversation ceases. She returns to the bureau and takes out the turquoise blouse of Mme Matisse. Changing into it from the white blouse of Sargent. She is employing the most delicate weapons.

From her bureau the turquoise blouse of Mme Matisse.

But it is not for me the blouse under which she has concealed her weapon. The weapon is for me. The blouse is for the young man who now enters the room. Tossing his raincoat onto a chair he comes up to her his eyes brown deep brown with the greed of depth and he turns for her the seductive lip placing it that full lower lip on her mouth where the narrowness of her upper lip is drawn, its faint hint of stinginess. She opens her lips and the cottony message flies out. He catches it and together they watch him toss this message into the air. They watch it fall apart in the air, turning the words into wisps. They laugh because they are free.

What happens next I conceal from myself. I give them just time enough to go into the kitchen for the ice cubes, for him to reach into the icebox for a piece of cheese or a slice of lemon. I can only bear the ice in the glasses and the tap water running. Perhaps a minute more. They sit beside each other on the sofa. He runs his hand over the ridges of the rug, the rug from Beirut Miriam had thrown over the sofa. His hand coming closer to hers which is picking at the silk flower pattern. The hands meet. I could not see whose hand was first. I had blinked just slightly that nervous blink I have nowadays which first caused me concern, but then I read it was good to rest the eyes by blinking, to blink as much as you like. The habit caught me in an unfortunate moment and when I looked again his hand lay on top of hers.

It was then I felt the strength of the weapon. Its narrow blade swifter than the blunted ridges of the nutmeg grinder.

76

"Having visions on Sunday is a way of outwitting Time." Eustace put his legs up on the table.

Burdened. He felt burdened with the weight of the biography he had read the night before, turning its pages, carefully scanning the photographs, to obliterate the scenes of that afternoon.

Sympathy stretched toward the book's protagonist. Morgan placed his head in his hands, rubbing his eyebrows back and forth, then circling and circling his eyeballs with that familiar victim's movement that seeks release from all those details panning into his head, those real paragraphs with their ache and stress. Apparitions! How much he preferred them.

And here had been lived this successful life, played out on so many stages, a life of luxury and pageantry that as its end neared had caused its progenitor to cry out in despair, "You ask me about my life. I have had no life."

Morgan supposed it was true. The one who lived the lie knew the truth about it. Knew all the artifices, innuendoes, padlocks that had been used to conceal the secret of—*nothingness.*

In this particular case Art had not been a solace. The profession, reaching a pinnacle in the chosen profession, did this often lead to desperation and emptiness? Did Art's long life and man's short career run in such different directions. The unfinished Art and the unfinished Life, moreover, the life broken off, terminated, then Art alive and muscular beside the artist's skeleton. Yet did they not breathe down one another's necks? Once in awhile, in gratitude, he supposed. And in mutual need.

He felt heavy, sleepy, stupid. With the glisten of the day outside and the lullaby wind lilting through the doorway. Somehow "not being up to it." The vision blurred, streaked, things arriving to him in patches. The day at half past three so ebullient, dashed in and out of buildings, casting its eyes into the open spaces.

Probably he was unaccoustomed to this rinsed air, like young people's hair, constantly washed and tended, fed and brushed. His own hair falling off, giving up.

Why couldn't she be coming around that corner, parcels under her arms, packages and fruit, a pineapple with its green locks half out of the bag. A lettuce curl. Taking those short steps. Other people hurrying past her.

Once Penderal had observed, "A lady is never in a hurry." Amusing considering the rapid pace set by his own wife.

Instead there was the dog running on the roof. And yes, walking with long strides, today her hair caught in a queue, slowly, deliberately, yet the stride was so long she was never outpaced, his neighbor, Helen. Even looking down from a height one can determine if known who the person is. The identity being that intact and separate so he could pick out Helen on the sidewalk from the women who walked behind her. Even with this pensiveness her walk held to its character.

He thought he would take a pill, to postpone things for a while.

The pill might bring on sleep and he would dream. Then when he awoke he would analyze his dream. He might even find a solution in sleep. Miriam had remarked about dreams, "There's something going on all the time, and it's better to know about it." In nightmares the data might be very profound.

He was weary, weary with himself. That was the truth. The biography had certainly injected its pain and ache; it hadn't been a cheerful book. None of that upstairs and into the salad. However, he couldn't lay the blame there. He was weary with himself.

With Cézanne he must continue to seek "a harmony parallel to nature."

Today he was out of harmony.

77

Those eggs need more mayonnaise.

Morgan Flew, what do you look like? Shoulders stooping away from head with its fine light brown hair. Grey eyes. *Les yeux gris.* Color of Paradise. Medium all medium. Did you see the War close up? Is that hand capable of willing "excellent and honest effort"? With white knuckle and blue ripples of veins.

"You know I love a cast in the eyes . . . "

With Dark astray in the Hawkesmoorean invention: managing to make a square tower look rectangular. Morgan trailing along with his incurably low blood pressure.

From time to time coming to grips with Dark's persuasions, creating a rough, tough little building out of post-and-lintel language with logic and originality showing up on the outside.

Then the journey into space, the architectural dream composed of illogic leading upward and out. Even creating an artificial inequality between Dark and Others. With the look of a church, and its means.

Collecting friendly pieces of melancholy from the ash heaps.

Setting up tensions between squares and columns. Grumpy with the circular where it won't fit.

Finding a way through the plain arches . . .

Being careful not to let one talent swallow up the other . . .

Dark retrieved from the ragwort. Turning on to the motherwort.

The long foot pointing out the direction.

Chewing at distances from the generous interior.

Possibly a one bottle man inhabiting a cave.

Mostly limbering up, feeling his way, startled by his own implications.

Still agile at leaping the humps. And soft, too, with frequent remedies nearby.

Turning up the lights as the eye of the storm passes over.

Then adding the mayonnaise as an after thought, like a turret.

One could claim with almost certainty the extensions with their groping and difficult adjustments were the product of his practiced hand. Miriam—for instance—although she might quarrel with the concept would no doubt agree. In all honesty. Inhabiting one of the wings and familiar with the walls. For such a long long time. From the beginning . . .

Their favorite walks near the narrow hedges, up the drive where the taller trees hemmed and the grass was murky with valor, accepting its rationing of sun.

Sipping coffee on the terrace protected from the wind, or on the sun porch with its veilings and warmth for the winter days.

Ah yes, Miriam was private to it all. She could find her way even where the space was cut off into closets. She had been so initiated. Also her willingness once she had understood the major renovations. Suggesting subsidiaries herself.

So far as the architecture of their relationship went there was hardly a fault. The seams were welded, a slight sway permitted where tension might exist; there had been judicious planning and allowance even for the unexpected. Like everything nowadays the cost was higher than the original plans had called for. Which is an understatement. The costs had been prohibitive. Despite all, they had maintained their center of gravity.

Which says a lot for them, commented Eustace, when he had learned there might be a momentary shakiness in the structure. Frankly with Morgan's determination and fretfulness over details, which, I must say, he is inclined to bungle if she didn't hold him to the line, it says a lot for Miriam's stability and balance that they've managed as well as they have. You remember the bit about Violet Wishing, that required tact, Miriam wasn't about to shake the timbers over that.

Clarissa Harlow who had got married to her soccer player that summer agreed with Eustace.

Morgan has a tendency to fabricate. And you and I know he runs around a lot. That way he picks up some strange ideas. He's not one to put all his nails in one coffin. No, not our Morgan.

His hypochondria developed some curious arpeggios, if you'll recall last winter, murmured Mewshaw.

These friends had draped themselves around Mewshaw's ancient Morgan. A car Morgan secretly believed he had been named

for. Mewshaw's Morgan was kept in fettle and clutter with constant trips to the garage and a few furloughs a week to maintain its strength. It had a way of pointing its nose and taking the lead as Miriam had observed. They frequently went out just to sit in the old car. Or rather to take turns at sitting in the old car to keep it and themselves company. The Morgan was a better place than most to discuss Morgan. Clarissa had brought along sandwiches and her husband whose name one tended to forget was picnicking under the bonnet.

You're going to need new straps for the bonnet was his practical contribution.

Eustace asked where Morgan obtained those Australian notes he, Eustace, had observed in Morgan's wallet.

For some reason the continent of Australia always led from one thing to another. The others became speculative about the notes from Australia. No one having been there. Mewshaw had come the closest when the cab driver taking him from Kennedy airport to the city had asked him if he were Australian. The friends had frequently pondered this rather severe observation.

They were all curious about the new Sydney opera house. Clarissa, Eustace and Mewshaw had read *Kangaroo*, and surprisingly Clarissa's new husband was authoritative on the backlands. He had learned about them from reading an Australian detective writer in whose stories the detective came from aborigine stock in the outback.

Then there were the "flying doctors" and the invention of teaching through television. Alert little minds sitting in small warm rooms surrounded by empty dusty land hearing the "teacher's voice" describe the Vatican.

I suppose, said Mewshaw, we regard Australia rather in the way the British still view us. Less jealousy with us, naturally.

Patrick White. Germaine Greer. Joan Sutherland.

On the whole I think I prefer New Zealand, was Clarissa's final word.

Do Melbourne and Sydney have much in common? Mewshaw asked on the way to the garage.

78

A Letter from Jacqueline
arrived bringing with it a blend of nutritive and non-nutritive sweeteners.

She regretted the unpleasant episodes of her former stay—although it had been delightful up to the last minute.

"You have no idea how we provincials look to New York. Like Nineveh or Tyre for those of us who live in Wichita or Grand Rapids."

A coincidence that she should mention Tyre. I had only last night come from dinner with friends who were excavating at Tyre when forced to leave by the civil war ripping through Lebanon. Personally I preferred Balbec. (Although it had been at the nearby village where I was offered a Fatah pin for my tie.) Balbec being more decadent has a dubious sexuality. These thoughts have nothing whatsoever to do with Kansas or the Eisenhower College at Lawrence. Merely that forces beyond my control cause me to swerve from the subject of Jacqueline.

I am reminded of my dentist who in the midst of an excavation exploratory and expensive interrupts his task to call to his secretary to have "the rug delivered tomorrow."

Now a fly interrupts me. I chase it out the window.

A long uncluttered weekend. Silence. Occasional showers. From time to time during the day I reread Jacqueline's letter. I could hear her harsh accent. Repeating its obsequities, pleadings, jarrings.

Assuming I did invite her, how long would she stay?
I was enjoying my solitude. Or was I?
Are interruptive influences for the good or bad?

I went outside on the terrace for a stroll. Pacing the terrace, picking up the rubble, the broken off pieces of brick, emptying basins of water, brushing off the air conditioner, hosing down a

section or two of the brick heavily encased in city dirt, I pondered the problem of cousin Jacqueline.

I could see her shadow on the terrace, and then the rim of her skirt turning in at the door. A laugh like the roll of a garbage can bounced out and a pebble she threw hit one of the windows. Over there her heavy tread had loosened the brick. There was a split in the canvas chair where she had sat and a few hairs were caught in the canvas. The whisk of the broom stirring up debris as she sought to compete with the cultivated terraces of my neighbors. A lemon, half grown, fell off. And that too was her fault. I experienced the darkening of the sun, the scuttle of the clouds and intermittent rain. She controlled the weather, especially an unpleasant wind I had not expected.

I was strongly tempted to telephone Miriam for her advice when the telephone rang. It was Jacqueline's cousin, Hubert, who told me that Jacqueline had tripped on a rug, fallen and broken her hip bone. She was at the hospital having one of those pins put in and she would be hospitalized for several weeks. After which travel would be impossible for some time. He knew this would be sad news to me as Jacqueline had told him how much I admired her, missed her, and had just written asking her to spend a few months with me.

The room became soggy with relief.

Almost I could hear Dark emitting a purr as the two of us settled into our unruffled sanctity. I admired my selflessness.

Hubert was the cousin who went around saying, "I haven't got a clue." There were strong inclinations toward secrecy on that side of the family. Jacqueline's fall must have impressed him.

79

I saw you first! cried Miriam.

By the law of coincidence that rules all cities, Miriam and I met in front of the statue of Simon Bolivar in Central Park.

Wasn't it more advantageous to "see another person first," because there would be more time in which "to compose your face"? As compared to "being caught with your pants down"?

Her raincoat was so unwrinkled and clean I kept looking at it, wondering if it was new. I hadn't reached the face. Yet I must have, because nearly sideways I commented on the cleancut look of the face, almost part of the raincoat, rising out of the raincoat with the pride of ownership.

How does one kiss on the edge of a park, near a carrefour, in the middle of life, after a misunderstanding, watched by a South American General and fortified by several thousand novels?

I was ecstatic as I realized this wasn't one of my *scènes imaginaires*.

80

> The center of gravity should be two:
> he and she.
>
> <div align="right">CHEKHOV</div>

Miriam is reading a cookbook published in 1920, *A Thousand Ways to Please a Husband*. The illustrations evoke that eager young just-setting-up-in-life middle class on the fringes of Sinclair Lewis and far from the exotic dispersals of the Jazz Age. Miriam thinks this book will be helpful and "set her straight," even adjust the temper of normalcy we so constantly raised and lowered. Therapy! She reads me:

"Home at last!" sighed Bettina happily as the hot and dusty travelers left the train.

"Why that contented sigh?" asked Bob. "Because our wedding trip is over? Well, anyhow, Bettina, it's after five. Shall we have dinner at the hotel?"

"Hotel? Why Bob! with our house and our dishes and our silver just waiting for us? I'm ashamed of you! Our extravagant days are over, and time has come to show you that Bettina knows how to keep house. You think that you love me now, Bobby, but just wait till you sit down to a real strawberry shortcake made by a real cook in a real home!"

Bettina fastened a trim percale bungalow apron over her travelling suit and swiftly and surely assembled the little meal.

"Dinner is served. It's a pick-up meal but I'm hungry, aren't you? And after this, sir, no more canned things!"

And Bob sat down to:

<div align="center">

Creamed tuna on toast strips
Canned peas with butter sauce
rolls butter
Strawberry preserves
Hot chocolate with marshmallows

</div>

Miriam! You're crying!

Through her tears she said, The reason I'm reading this to you
is so that you will understand me more, I mean than ever before.
This book was my mother's. She began her marriage with it. I still
make creamed tuna on toast strips. Real toast strips. That earnest
hope they all endured. The tenderness of marshmallows. The
confidence that doing one's job in the kitchen well and nicely
would cater to the marriage. A *nice* marriage. One hundred per-
cent American. And there isn't a drop of wine or booze in the
book. She broke off—Listen, here is one of my favorite chapters.
Especially the last sentence.

Bob Makes Peanut Fudge

*"I usually complain when it rains—I have that habit—but I must confess
that I like a rainy evening at home once in awhile," said Bob, as he and
Bettina sat down at the dinner table. "Dinner on a rainy night always
seems so cozy."*

*"Liver and bacon don't constitute a very elaborate dinner," said Bet-
tina. "But they taste good for a change. And oh, Bob, tonight I want you
to try a new recipe I heard of—peanut fudge. It sounds delicious."*

*"I'm there," said Bob. "I was just thinking it would be a good candy
evening. Then when the candy is done, we'll assemble under the new
reading lamp and eat it."*

"Yes, it'll be a good way to initiate the reading lamp!"

Thus Miriam and I began to reconstruct our days.

She in her percale bungalow apron and I in my stiff collar home
from the office. It meant many consultations with Bettina's books
from *Home at Last* through *A Guest to a Dinner of Left-overs* to a
Handkerchief Shower, The Firelight Social, until we reached *The First
Year Ends.* We even had a *Waffle Party in the Afternoon.*

Bob's anniversary words to Bettina had been ones of praise:
*"You've realized marriage isn't a hit-or-miss proposition. It's a
business—"*

Brick ice cream!
Someone whose name I know very well, yet refuse to reveal to

myself, said: "After all Remorse is only a certain way of looking at oneself in a mirror."

By cubits and strategems Miriam and I withdrew from that her and that him who given further opportunity might have terminated what was both numinous and sobering in our future.

Like Bettina's husband, in the first humid rainy days of summer, we tended our tray of consoling sweets.

81

We retreated to the peninsula.

As our days began their experimental ho and hum with pace and halt, we found cause to add our reparations to some nearby ruins. Excited by the antique murals we sketched our own; enthralled as Sir Arthur Evans upon his archæological site, who not content with the buried uncovered, needed to add his own satyr and bull, paint his own godlike pranks upon Cretan walls—so Miriam and I in convalescence repaid the island gods with mirth from which was subtracted all bitterness.

Upon what had been a decline we decorated outrageous stairs.

82

Lustrous Polychromes

Cypress, eucalyptus, magnolia, oak, olive, palm, sycamore, orange, lemon, jacaranda, pine, yucca

Bougainvillea, gardenia, geranium, camellia, rose, oleander, succulent, begonia, sage, thyme, heather, pansy, pink

Fog. Sun. Heat. Coolness.

Mountain. Sea. Canyon. Desert.

Dry. Parched. Green. Watered.

Smudge pots. Acqueducts.

Porch. Balcony. Grill. Gates. Hedge. Stucco.
Tile. Wall.

Deep shadow. Ardent light.

Somewhere beneath this radiance there ran still a turbulent current which erupted in my dreams. Fresh landscapes would appear and on them posed portraits of my friends, often in threatening attitudes. Animosities and ambivalences advanced and retreated and morning found me gathering sums of paranoia. This unpleasantness fitted so ill into the scenes of my waking life composed of friendly cats and dogs, mourning doves and the activities of the natives vigorously commuting from mountain to beach, driving their campers and charming miniature cars, the illusion of health, if not happiness everywhere.

Finally arrived a dream which banished the nightmares, so comic and compensatory it was.

I dreamed that Tony Smith climbed into a dirgible whose name was lettered: UNDERSTANDING.

Perhaps it was I who had arrived at "understanding," of what I'm still not sure. I did manage to cut my dosage of yellow pills, although certain illusions were hardier than others and when they slipped away left a silhouette to haunt me.

Something like a yellow truck charging into the distance and leaving in its wake a cloud of dust.

Or the mocking bird flying to its tree leaving a white puff of feather on the tile.

Or the surfer plunging into the wave and from the shore only his heels visible.

Or the brown and dried camellia flower.

Or all refusals to forfeit their identities.

The empty milk bottle.

The empty carton in the closet.

The word without its sheaf.

Blue hour. Violet hour. Green hour. Days without these hours.

The key word flailing in air before it dropped from the foreign tongue.

Blue hour. Violet hour. Green hour. Hour of illusion.

83

Eustace Worthal came to the peninsula.

This time he told us his project would be to find "signs." He wanted to discover those "signs" which would be his alone and would correspond to no one else's "signs." Then truly he would be in the realm of plastic inventiveness. He wanted his horizon to enlarge so that he could place his "signs" on it and they would create a new kind of space—space that he would call plastic.

He had been thinking of his project for weeks in New York. Each day he had tried to discover a new region into which he might enter, as a traveller would traverse the new, the unfinished South American highway. He would find neither priest nor explorer, but natives with whom he might communicate only by signs. His job, circumscribed as it would be by language, would be as difficult as that of the early Spaniards who cut El Camino Real across Mexico and into California. The missions he would erect so far had no scale or model. He would name the signs after himself, so that any wayfarer coming across them might find his location.

The rhythm of New York with its inner and outer currents, on the one hand over-stimulating, and on the other dissipating, had begun to hinder him.

Eustace had selected the peninsula because we were there and it would be necessary to test his discoveries on sympathetic ears. Also he wished a location whose flora, fauna, weather and temperament would be as unlike the eastern seaboard as possible, and yet would be found not too distant from what we call civilization.

He also wanted to watch the movements of other natives, whether rapid and disconnected, almost hoydenish, as in New York, or inclined to a slump and a weighty rear as in other parts of the U.S. Frankly, he confessed, he would like to look at some healthy faces on which life had not writ large her expectations and experiences. Here the year round exposure to sun would conceal

any evidences of a superior, hence anguished intelligence.

He discussed all this with me and Miriam while the lawn mower at the neighboring villa was plowing its motorized way and the noise caused me to lose a few of his clauses and conjectures.

Curious, itsn't it, said Worthal, that everywhere you go there are lawn mowers. And what is more mysterious they are constantly employed.

We explained that each villa had its separate day for lawn mowing, so indeed it did seem as if one god-like mower were moving at all times.

Those raspy blades and turf cutters might lead me to one of my signs, mused Worthal.

84

Also I welcomed Worthal because Dark was showing "signs" of restlessness. To my annoyance Dark was at its most responsive when my personal life was finding it hard going. Any flare up with Miriam brought instant sympathy and a creativity, an almost careless use of the imagination, that carried me to the brink and over it with an ease I could only admire.

Perhaps Dark and Worthal's embryonic "signs" might prove faithful to one another.

Dark could become a real annoyance. It was the critical eye at all times turned on. If only for a few days I could rid myself of this presence, this *energy* called Dark. Almost I envied invalids with their nurses. Not the neurotic, inhibited nurse. But those who by temperament were suited to the profession of nursing back to health, those who received their tribute in the sick person's progress, and those especially who maintained an evenness leavened with an intelligence. Ah! Almost I desired such a person for myself. Yet was not Miriam . . . I did not wish to admit that frequently I cast her in this role.

I suppose I was thinking about nurses at this time, because on his way, as he had assured me to a "sign," Worthal became ill.

His illness surprised us by becoming more serious. A nurse was called in. Poor girl, yet fortunate too, because she could not translate his raves and rantings. She merely found an eccentric stranger not in his top form. Or so she thought.

85

I had learned to take the temperatures of my own illnesses, those that racked me daily. I had raved at my body for being such an idiot, such a victim of the benign tyranny of my mind, had wept conscience stricken through the night for the sufferings I had caused myself. Rocking as I did to each single self directed vibration, there could be but little time remaining for the misadventures of others. That is unless they were forced upon me as was this illness of Eustace. The flaws—flaws!—in my own character had obstructed my views of the feeble mis-alliances others around me had sought. But Eustace! I loved him. I admired him. I laughed at him. And now the damned fool was sick. Worse, he was taken to the hospital.

When this happened I began to organize what I had guessed or known about Worthal's disabilities. His mind with its immense agility had, of course, tried to throw me off. But now that I reviewed his case I could find the threatening notices, the postings, the absurd camouflages, the discrepancies, the dissemblings, falterings. Eustace! He had been like some corpulent body, in his case a skeleton, we should have placed in a carriage and sent off with tender wishes to the nearest spa. For that was how he played it. His mordant humour to our inclemency. The weightiness of his slender movements. His Tristram Shandy. His thirst for what was purely human concealed within his misplaced artifacts.

86

I was interested to learn after visiting Eustace at the hospital that the words Pride, Honor, Courage, have less to do with life than with death.

It is our burdens on time that leave us so empty when the basket is full. When time is so free, so cavalier, so energetic in its wanderings.

Death, the other relative. Never before had I watched Death perform its antics. Film, television, theatre, had admired Death for the stealth or elegance of its approach. Death as I saw it was watching over us. When I closed the door, did I know that Death would seize the moment? Leaving the hospital, walking through the sunlight, scented, acrid, of course I knew Death was following me. And I faced all the known, the acknowledged movements of Death. For everyone who watches Death there is no type, body, category to guide. I found I was using words I would never apply to life. Courage. Bravery. Invincibleness.

The eyes that would not see. Only spots of dark and light. The dots on the telephone. Dots on the medicine. An entire life reduced to seeing dots. Yet these were Eustace's signposts. In their own way they had selected him.

In his hospital room seated on a chair, draped with blankets. It is possible to speak of the nobility of a face, a mien—in fact to be surprised by it. Before his illness I had paid little attention to the face of Eustace, the visage (as the French so delicately put it). I was listening to what he had to say. I suppose it was the area of the mouth I most noticed. And ears. Eustace has large ears. I was not complimentary. His gait was stooped with thought, as Wordsworth might have observed.

Suddenly I found myself thinking, and then saying out loud, You look like a King.

Some King, said Eustace.

These words endeared him to me. As one day when I came

upon him lunching on his usual dates, figs, nuts, I said, You really should have been an Arab in your tent.

Yeah, said Eustace, except I wouldn't be doing the same thing in my tent.

He asked me to fetch him from the shelf his "treasure chest." This was a small cardboard box decorated with Christmas trees. A gift box. From it he took his teeth and hearing aid.

He had that gift of arrogance to transform whatever came his way into an object special to his view. I believe this was what he was finding in words, this translation of what he *conceived* to be. This transformation whose voice he could only hear with the aid of a small battery. To my sorrow I now found he could not even see his "signs." If too much time were left the signs would disappear into the mist.

Now, he confided, he could find his "signs" only by way of dots. Although faces had become indistinct and the room blurred, yet he might trace an outline of his signs composed of dots. I saw the marker he was using.

To present his courage more strongly in all its sternness, I can state that he almost had found a happiness in the reduction of "signs" to dots. The fact that his hemisphere had narrowed or rather was circumscribed in the extreme, very nearly pleased him. He had reached that state of near to nothingness he once had described when crossing the "terrible sands" in Arabia. The presence of nothingness was all there was to comprehend. This nothingness as he crossed dune after dune came to add up to a huge something. With the departure of all vegetative growth his dependence upon himself had been complete. And there within his mind, or what you may call will, or finally *loss* of will, he had found refreshment and oases.

Eustace said, I know the mountains are there. I just can't see them.

He took his marking pen and asked me to put dots on the telephone numbers. He could see the dots, not the numbers. Using dots, however, he could reach, as once the path had been led by numbers, infinitude. An obvious discovery, he disclaimed.

Eustace said, I wish Miriam would visit me. Her name is like water.

Eustace questioned me why he wished to go on living.

Dessicated, sand stripped, the last signpost was a stranger, his nurse. Yet after this last dune there would be the village. He wasn't certain if he wished to enter it, or if the tribes were friendly.

You know the difficulty, he said, I've always had in the U.S. with its attitude toward what is called my eccentricities. The difficulty in holding a job, or the mistaken aids often finding their way to me that confused and frightened.

And yet. This village I am nearing. I wonder if the inhabitants are friendly.

I noticed the red dots on his watch. The watch was fast. He smiled when I told him this and with a regal gesture indicated that it didn't matter. All the same he insisted I correct his watch.

It was important to me that each apparatus that surrounded him should be accurate. The accuracy of the oxygen explaining to glucose the need for accuracy as of a watch.

As Eustace had been accurate with his "signs" or had permitted them to distribute their accuracy to him.

87

That it should be Eustace who shadowed the landscape, I hadn't bargained for that. His dromedaries lined up beside my cypress. I had not expected this.

The rose garden. I had walked behind him when he had ambled in his monkish way to the garden a little separate from the other flowers with a hedge around it.

I had observed his struggle to commune with the various species. Through his knowledge the roses came to have a hold over me, again unexpected. Despite their fragrance I had always held they could bore one, satiate with their ordinary scents, their obvious colors, their drooping or obstinate heads. Now that I had learned a little of their sensibility through my talks with Eustace, a respect entered my heart for these roses, the way a man falls in love with a woman who is desired by others.

Having formerly decided that roses had less temperament than beauty, I found I had changed my mind. Eustace lying in his hospital bed spoke the name of a rose I brought him, almost religiously, The Pearl, he kept repeating, The Pearl. And I began to guess an unfamiliar eroticism in his naming the flowers. Almost as brides they were brought to his kingly bed. Experienced luxuriant roses red waving their erotic petals; and the pale yellow roses, tending to his tastes that inclined toward the *exquise*; and the sexless white rose. The pale pink single petalled roses promising in their near adolescence, he would stroke their petals with the light touch of the man whose tastes verged on the *peculiar*, who experienced the bliss of waiting.

After leaving the hospital I would stroll his garden. The garden that I called his, untruthfully, as after all, it had been planted by the owner of the villa. Attempting in my fashion to commune with the flowers, their beauty, their banality, and the possibilities of their spirits. Not terribly successful, my attention often strayed to the poppies with their parchment colors, the strength of their

stems and the frailty of their blossoms. Although when it came to it the poppies when cut would long outlast the roses.

It was the heat, the gardener said. Dry desert heat drifting across the mountains. One sought the shade and it was cool there. Whenever I left the burning yard or garden and found an enclosure there would also be coolness. Birds flying from shadow to shadow. The roses preferred June heat with a little moistness. I thought of the gardens of Persia. The famous rose gardens. And yet I was told, there is no word for "rose" in Persian.

The rambler at my parent's house. A purple rose. Today I learned its name, *Veilchenblau.*

"Go lovely rose," but not to Miriam who prefers the illustrious hydrangeas.

Eustace improves. Is rehabilitated, as they say.

I continue my visits to the hospital, bringing roses to the nurses.

The difficulties of perambulation are made clear to me.

To walk around in order to fix a boundary.

I admire the lithesomeness of Miriam as she crosses the road.

I perambulate toward Dark whose neglected labyrinth these past weeks grew weeds.

My room, the residence of Dark, has suffered vandalism. The web of my presiding thoughts has been broken by an intruder. It is now my duty to restore the order.

I prepare my lies.

Nietzsche said we needed lies in order to vanquish the cruel reality of the world.

And I, although reality had been bordered with roses, am exhausted. Even Miriam who speaks the language of woman, as a Japanese woman, kneeling or profiled against the screen— threatens, pushes a reality that I must now avoid. The hospital visits had been costly, rewarding as they had been. The claims of reality, however, can become permanent, like the demands of an invalid.

What I need in the luxury of heat is some sort of Pompeian structure.

Its pillars and mosaics would reaffirm me. I must affect a design here in this villa.

88

The reality that surrounded me:
House, table, chairs, light, dark, heat, electricity, cushions, windows, driveway, shrubbery, floors, the gardener, Miriam Miriam Miriam . . .

My escape:

House fading into landscape
Night into day
Heat into cold
Miriam into Miriam
Morgan into Miriam
Water into bottle
Seed into bread

My voice fading into her eyes
Her eyes fading into my heart
My heart fading into its pulse
The traveller into the inhabitant
Now into next
Multiple into choice
Selection into reach
Language into silence

"Even words must perish" reflected Logan Pearsall Smith in his villa.

Basic retreats
A "third universe"

(Somewhere between what is believed or selected by the world and that determined by the simple unconscious)

Often called "a floating universe"
Concave replacement by convex

As much abstract as else
A celebration of the Sunday solstice
Literature as destruction of space
Alphabetic dimensions and their limits
Values seized by their identities
Achievement of ripeness
Disregard of forages as defeats
Subsiding of monetary battles
Moving my log beyond state limits
Challenging the upper and the nether
Recognition of dwarfism as reclusive

89

Will Eustace continue? This question was posed by Sheila Mulfinger who had graduated in the same class with Eustace. They had both gone to a State University. The new buildings on the campus had displeased both of them and neither had feared to say what he thought.

Asking if Eustace will continue is the same as asking if the Renaissance (fake) Humanities Buildings considered not earthquake proof would be replaced by the new Gothic constructions dominant today, thanks to Yale School of Architecture.

I suggested that Sheila visit Eustace. Perhaps their common training, or rather the quality each shared of listening hopefully for the truth to arrive in its ambulance, might console, even help him. It's no distance, I said.

I don't have my car, replied Sheila. And ridiculous as that may sound it's being repaired and as a consequence I haven't eaten for several days and my laundry has not been collected and taken to the laundry, or my skirts to the cleaners; truthfully I haven't been able to get to the bank.

Besides in this heat a car is more of a detriment than otherwise unless you have airconditioning, which I don't. They still deliver my paper and milk arrives once a week. I would like to mail a few letters. Perhaps you could drop them into the nearest mailbox. I'm nearly positive the brakes will be relined and that vertical movement taken out of the front, I mean the hood, resting as it does on a rather difficult wheel. That is the right word. I caught the word realignment. The spelling of that word is rather significant, don't you think?

Coming as it does at the same time as Eustace's rehabilitation, I could not help suggesting.

Well it's all relative, said Sheila. And we enjoyed a good laugh. The first laugh in many weeks for me. Here on the peninsula I was

rather inclined to smile. I showed my good humor in a delicate way. In grins, in frank noddings of the head, and by a permanent sort of breathing swelling out from my chest. This took in the properties surrounding me and their occupants, and I placed on them this smile and encouraging breathing and nodding.

Sheila and I had a good out and out laugh. Despite it being at Eustace's expense. Carelessness was what we shared. Or carefreeness. Since when had I been occupied by that?

90

I wore this carefreeness for several weeks. It had settled on me like the dust blowing in from the desert of which I was scarcely aware until I found myself writing my name with my finger in the dust.

The inventories of dust . . . the swift strokes of the straw broom as it swept the earth . . . the clay into which reached the tomato plants . . . pounding of clay into pot or brick . . . careful rich deposits . . . yucca perched on shale . . . a car moving from grass to pavement . . . its tires heating or cooling the cement . . . sand on my leg . . . sand filed against my ankle . . . sand resting on tile . . . the weight of tile . . . heavy here . . . thin over there . . . bird's beak pushing the cracks filled with bread . . . perishable only the mountains . . . venturing into haze.

91

This inventory went into a book I had found in the villa, called "Our House." The first twelve pages were filled with photographs of the villa Before and After. Contrary to all the laws, the present owners had made improvements. An arch here, a conversion there, a simplicity retreating before a sophistication of landscaping. Altered views, nearly negligible sightings, shifted so that the sea appeared at more varied angles.

A comparison of Puskin to Byron, as it were.

When the figs began dropping from the tree, I asked Miriam if she didn't think the time propitious for a visit from our friend and neighbor up the valley—or was it down the valley—Raymond Mortashed.

He should be calling on his aged sister, don't you think?

Not the one in the convent?

No, the one who held onto the family money. Rhoda. Wasn't that her name?

Of course!

Angelo told me that at one time the family had owned most of the land. As far as the eye can see.

Miriam always quivered just a little when I mentioned Angelo. He was a gardener of angelic disposition. When he waved his arms outward indicating "as far as eye can see" there was so much grace in his gesture that I would glance quickly to Miriam always to find her quivering and consumed with this gesture of grace. Well, it was true, Angelo was a fine looking man and had he been educated he would no doubt have become just as graceful in his double dealing as his compatriots.

He fitted into our need for the "primitive," the "earthy," the Lawrentian properties that usually attracted the so-called Northern temperament.

But back to Mortashed.

Angelo will know if Raymond is planning a visit. Shall I ask him?

He's usually hanging around Rhoda's kitchen.

What do you mean?

I suspect he likes one of the maids.

Angelo? But he's married!

He married early and is the father of three.

Which is more than one can say of Mortashed.

Mortashed's remaining a bachelor had always annoyed Miriam and I wondered uneasily why. He was a clever, amiable person. I suspect he was too thrifty to share his life with anyone. Thrift or parsimony of any kind did annoy Miriam. Fortunately for our ménage my thrift had pared itself down to keeping bread in the refrigerator or turning off the refrigerator when I left town. Or eating potatoes after they had sprouted. I did tend to mend things which had best been left unmended. I did have the watch that had attended me to college. But I did not have my first dollar.

When Mortashed finally arrived it was after a visit to Eustace at the hospital.

He was adamant. Rehabilitation! They're teaching him to walk toward death. Did you see the books in the therapist's office? *New Ways of Dying*, *Death Can Be a Benefactor*, *Insights into Dying*, *The Terminal Book*, *The High Cost of Dying*, *Wheelchair Recipes!*

He added, Is Death as bad as all of that?

I admire Eustace his refusals, his rages, his lack of compromise. Nevertheless I should like to see him walking about, cutting into the scenery, the awkwardness.

Especially his silhouette.

And his nighttime modesty.

His pitch.

He always makes me feel so mercantile, said Mortashed.

With his Presbyterianism he'll likely be gathered into the fold. Poor laddie.

Eustace is not yet dead, said Miriam.

She took us outside and sitting under the olive tree we ate gingersnaps and drank papaya juice.

92

Mortashed spent a week with us which he pretended was only a week-end. He was with us mostly, we gathered, to fortify himself for his visit to Rhoda. He told us she spells her name backward in legal matters, and signs her name *Adohr-able*. This was the year she did not plan to go to Portugal. She has many plans, he sighed. Going into the cow business was her first plan and its success has made the other plans multiply. Like real estate.

She sold another bit of land to the Methodist Church. They built a school on it which they claim to be the only "non-scholarship" college in the world. I had always enjoyed that site, he sighed, but of course I had made no plans.

What plans have you two made?

We plan to be here another month.

Will you return to New York?

We plan to, that is if I can complete the work I've planned.

We all sighed.

I plan on taking a nap, said Miriam firmly.

If you don't mind I'd like to sit here and read the paper, said Raymond. Then he added, My only criticism of your program here is that I can never find the proper place to end its paragraphs. The hours move or slide or jump or tumble, they leave me with no idea of their punctuation.

What would you suggest?

I think an evening paper might be helpful. Beginning the morning news at six in the evening rather confuses me.

Then, noting my frown. It's the walk into town in the evening. News of itself isn't all that important. But the walk is a pleasant divider. Then of course one can return with the paper. And read it later. In bed, for instance.

Bells, said Mortashed. Cow bells through the valley, and these amusingly "ancient" ones you hang here in the patio. Bells are important. Marking out the hours. The tribal invasions. Hours

when the land is peaceful, hours when it is enemy-struck. Hours when the church wails out.

Remember the bells of Illyria?

Eustace, no doubt hears the bells. Wherever his coast may lie.

Eustace isn't going to die, Miriam had said.

93

Eustace was dreaming of taverns and the mettle of strangers. He shared this mettle with them. It was his single foray into the acuteness of combat. He wore the mettle on his bony shoulders like danger.

Daggers, thought one of the nurses.

It was useful to carry a mantle; to be thin; to think; he still remembered his phrases. They would often rise in the night to curse him. Yet in the day they rested beside his wheelchair, ready if he signalled. They were the phrases that had accompanied his life and gave it direction. Not having inherited more than two or three, he had been forced to rehearse the phrases of others and adjust them to himself. This occupation had taken many years, actually, his youth. Then toward middle age he had started framing sentences of his own as guides. He had nourished these guides, feeding them from the lines he had cast out until they were opulent and exhaustive. After middle age they and others began sliding down the staff. He had caught each meaning as it slithered off. The difficulty was he had not been quick enough. Some had fallen into the grass. Yet he still had a goodly number. Rather stalwart. Hardy enough to resist the embrace of a hospital. He felt them clinging to him. Through the mantle of . . .

Paperwork it all was. Mere paper. The way dreams beset him wrapped in papyrus.

94

There are so many to thank, Eustace told Mortashed.

Mortashed pushed his eyebrows together and said, Yes.

Even Rhoda.

Even the idioms and the charts. Even the diminutives and the anacrostics.

I hope, said Eustace, you will continue caring for Morgan and Miriam.

The fidelity to Dark . . .

Ah!

I'll send you my glances, said Eustace, his hand touching Mortashed.

95

At supper Mortashed said, Let us never be bedevilled by ecclesiastical squabbles, and I knew he had been with Eustace.

96

Eustace will not die. Like Nietzsche he will organize his lies.
Either you favor Constantinople or remain Pagan.

97

How graceful is the tablecloth. Quietly waiting for us to gather. Its items distributed. Preparation in silence. Waiting for us who will break into its spell of calm. Whose conversation might be rude. Or quarrelsome. The tablecloth seeks to tame us. To remind us of charm, even the charm of life. A pity we shall sit down and begin to grind our oaths and prejudices against it.

To remind myself of the delicious morsels.

Begin to anticipate the feast.

Read Walt Whitman before going in to dinner.

Ask Angelo to tell Rosita to tell Marianna to let up on the garlic.

Don't read at the table.

Don't bring up any controversial subjects.

If Miriam decides to come down to dinner remember she is there and talk to her. (In a light and bantering manner.)

Remember the dinner table is no place to bring up the condition of Eustace, or myself, either.

If Mortashed stays to dinner discuss food and don't let him get away with "I prefer plain food." Or "Home cooking is best."

If you want a little more excitement you can refer to the few three star restaurants in which you have eaten. But only mention a few. And don't show your knowledge of national cuisines. Let Mortashed do that. After all he's been to Iceland and you haven't.

Eschew the bread.

2 glasses only of wine.

After dinner you can say you are going to your room for a little nap. Or, if you prefer, to consult a few sources for Dark.

98

Our residence on the peninsula had commenced with a cookbook. It was just as well to end it with dinner.

What had we accomplished?

Perhaps a more stalwart companionship? The worry about Eustace might end at any moment. Or it might continue with a postcard from his convalescent home . . .

It was becoming increasingly more difficult to continue to work with Dark. The days thundered by in their heavy yellow muslin, no edges or rags. Then abruptly the shawl of cold.

Finally I understood "The Lotus Eaters"; that is, I recognized "A land where all things seemed the same." Here it was impossible to increase a holding on life or literature. My anxiety, formerly dependable, began to crumble into "golden sand." My relationships with friends, lovers, natives, were gilded o'er with a breathlessness that permitted no egoistic interruptions. I was becoming quite a common thing—a thimble, a tomato sauce. Where had disappeared my hijinks, my hieroglyphics, my unravelings from chilly dawn to chilly dusk? Even disastrous conversations were sickled o'er with no thought or menace, drifting out in murmurs.

My desires, my appetites for so-called pleasures, had dwindled down to a whim for peaches. I became fascinated by Miriam's unhealthy appetite. For her the bread was baked, the olives fell, the rooster crowed. Morgan lay supine in his canvas-slung Lytton Strachey chair. No doubt while he was retreating into the canvas chair Miriam was escaping down corridors of food, digging her way out.

The breezes deposited nothing.

Was that a harbor whistle? A steamer sidled past. A steamer going where?

At the same time, after our return to the city, I'm certain to praise these days that spilled into "The Fountain of Bandusia." No Dog-Stars shall I recall.

99

(Act the first)

Miriam: Noble one whence go we hence?
Morgan: Yon ship repaireth to our harbour and methinks there if fortune
kindly nod, its Captain shall heed our request and beg us board.
M: Certain art thou 'tis a friendly bark?
M: As certain as Sirius, the Dog Star, rises that brings the heat at
noon.
M: E'en now I believe the air is fresher.
M: Once aboard we'll take the breezes into our heads and glow with
prideful words that thicken now our bellies.
M: 'Tis odd. Though I long for homeland yet loathe am I to leave this
land. An enchantment lieth here that graspeth still my girdle.
M: A like feeling steals o'er me. 'Tis as if we live half awake and half
in dream. The dream is here and there awakeness tarries. Yet must
I shake this dream and hasten to the harbour.
M: Sweet was our rest, though troubled by Eustace's sorrow. That
lent a shadow to our ends.
M: Eustace hath shaken the pale shroud that awaits all and now
retreateth to his friend, the noble Mortashed, who with his sister,
Rhoda, shall his trembling members mend.
M: And thou to whom I now appear like Imogen, newly drest and
garbed with faithful rubies, to thee I pledge whatever place to
which we hie, my soul shall constant be. My thanks, my lord, for
all that thou hast here wrought. The silent cypress, the emperor
moth, the olive, the flowers that breathed a calm upon our days
and sweetly stirred our nights. To this summer memory shall I go
when winter shrieks and curses round me blow.

100

One must travel far while loving one's
home.

APOLLINAIRE

After our classic itinerary the vines of the new world pressed
against the screens.

Now that we had returned it was necessary for us to make "a
place" for ourselves and the vines were what we hid behind.

Had we been missed?

101

What we had missed . . .

The Rape of the Elevator: Attitude toward Portugal

The decoration of my elevator transforming varnished wood into bungalow wallpaper stripe. I expected to be let into marbelized halls with faucets of gold.

Recognizing another addition to the dreck of the city, I began to teach myself to ignore the elevator. At the time when the elevator had varnished wooden walls, one day there shone the word WRITER. The only graffiti to scorch its walls (although over the years of its servitude the usual sentiments had appeared to be snapped up and wiped out by competitors), WRITER was a survivor.

It had become—was all—so much structuralism.

Barthes writing of himself that after the immense detour of his theoretical writings he feels he has won the right "d'être bête."

So indeed climbing over the areas of symbolic codifying of Dark, my adventures in the lisible, jointures with the putrefying heaps of collective thought, attempts to define ultimate complexity or complexities of Dark, I had earned the right to be modified to the *parole* WRITER.

Now with this filmatic scenery of the elevator, what was scriptible was wiped out by the give and take of the city.

Well the elevator was good for a laugh or two. Until Eustace or his successor came up with another *sign*.

The superintendent of my building is Portuguese.

It is under his reign that the wallpaper elevator appeared.

What do I think about the Portuguese Question?

Always persuaded from any political stand by the letters *lh*, *nl* occurring together.

And usages like Popcorn or Copout . . . fatal O's with their historical assoc. Like Nato.

The raspy movements of Portuguese toward obstructing

consonants, in the opposite direction from the Spanish.

Glimpsed through the open door the iron grillwork of Portugal each day I enter my building. Green plants. Bright walls. Smell of bacalhau, the cod enriching the Regency lobby. Hearing the rough sounds of *lh*, *nl*, "gravel" sounds I once had written.

What do you think about the Portuguese Question, Morgan?

What do I know about Portugal? The setting for *Candide*. The earthquake destroying 75,000 lives. One of the major disasters of the eighteenth century Beckford's Journal.

Fado, murmurs Miriam. And San Francisco. The air of San Francisco.

The government is in Oporto.

We walked toward the elevator.

Moviemento Das Forfas Armadas

I hate the elevator.

So do I.

It stripped me of my occupacion.

WRITER has been exiled like Soares.

The elevator opens. We enter with our bowed and mournful heads. Jesu Christo!

The elevator has been raped! Gone are the bourgeois scenes from the cage of my building! Erased! The wallpaper! What anger! The Counter-Revolution to the Counter-Revolution! What government now is in power?

Could it be the MFA who have torn the wallpaper, scraped and burned the walls? I lift my eyes unto Oporto.

Much good that will do you, scoffed Miriam.

I thought perhaps a cloud might settle on and obscure the Rio de Oro.

What really happened to my elevator?

Today three weeks later the elevator has not been repaired. It remains erased, stubbled, revolutionized.

General Spinola is in Brazil.

The son of the superintendent brought to New York at the expense of $4,000 wishes to return to Portugal.

His father screams, You will not go to Angola!

The son of the superintendent attended a march against the Communists. He took a bus to Washington. He marched. He met a beautiful girl. Portuguese.

Father, he said, I have found my beloved in Washington, capitol of my adopted country. I shall live here forever.

She has, says my superintendent, creasing his nose and lighting his eighth cigarette, "a house across the river."

The elevator has not been repaired.

Tonight I'll have gravel dreams.

Tonight you must dream of Supervielle. I'll give you one of his lines.

Why are you so involved with Portugal?

Why do I dream of the Rio Plata? Ecuadorian silver? Venezuelan mines? Why? Because I believe the New World is Somewhere.

Before going to sleep, Miriam clasped like a silver bracelet around my arms, her back in Cuzco, her strong swimmer's arms offshore the whole continent, I read:

"Arnold Hammer announces to his constituents that after the Russo-Scythiano (sic) coup he has now his own travelling circus of 19th century and (earlier) painting due to arrive in Caracas at any minute."

And why, I asked, next day sipping my maté through a silver straw bought in Yucatan, should the question Portuguese insinuate its torment into my life when New York City was "going down the drain."

Why indeed, I pondered, placing the glazed Japanese jar modelled on the Chinese on top of the impedimenta of Dark, should I concern myself when the fiscal year was drawing to its climax tomorrow? Rosh Hashanah. Tomorrow and my birthday.

Tomorrow when New York City clad in its gypsy rags and togs, lying on its bier of ash cans, amid the rubbish of Goya beans, hot dogs, like a pizza its jagged edge where the sauce nearly obliterated bore the teeth marks on its journey to the gutter, its ears rinsed by familiar screams, breathing the thick germ-laden air, like Calcutta slipping toward the river's poisoned waters, eased off its beggar's throne is "going down the drain." Why should I care about Timor, Angola, the ethics of Malaysia, the marriage of Prince Charles, the athletics of Norway's royals, when all the sap here was running out?

Into what lair would Dark creep? To embrace the greater Dark.

102

I heard through the dead silence, the soft
drip of the rain and the tremulous passage
of the night air through the trees.

<div align="right">

WILKIE COLLINS: *The Moonstone*

</div>

Listen!
It's only Autumn russeting.

103

Oh, if you children only knew
About the coldness and darkness
Of the days to come . . .

ALEXANDER BLOK

Dark being edged out by White.

Impossible!

I had thought if I could insert a fleecy thing Dark might find more comfort. Instead I kept finding white threads, and worse white soft lumps like cotton. Comfortable, undoubtedly, but *white*. And the white multiplied so fast. Dark the tyrant, Dark the fastidious, kept turning his back, refusing to face that at all. Pretending he was so secure in his kingdom nothing could upset him. No riots or revolts. Yet White kept appearing more frequently, the intervals shortened. It was as if Dark would find himself in the clear, then turn a corner and find White waiting. There was no peace now. There was no security. Small breakdowns occurred. Then the holes were found. Then the gaps. Everywhere. Even the ceilings crumbled showing their white behinds.

Swimming in September's chilling waters I realized I must organize an attack, or—and I considered while using the long stroke I was so proud of, and kicking the water not too hard, a little off shore to the left, raising my head, laying it on the water then into it, diving for clearance, sand grains in my hair as it fell over my eyes, eyes reddened with salt, yet sturdy too, like the legs (the legs go first was what Kenneth had said) arrange a marriage of convenience. This settled I celebrated riding the wave with such clarity as I broke with the wave arms pounding the water like

180

Santa Monica years ago, then the straight body shift arms at my side the wave a long ride and spewed out on the sand not bothering with safeguarding on the rush, coitus interruptus, but straight onto the sand and shell spewed. I hurried to Dark.

It was White whom I met first. White doing a turn at guarding. Gaudy White like a tourniquet.

White whose name is Eve.

Around whose name rests a certain fame. It was the tidiness in the beginning. Later it was modesty most admired. Yet White retained a simplicity (related linearly to heroines) natural to White and certainly not to Dark whose series of complications recorded on stacks of cards in my study would lead anyone to question if Dark intended in that maze to lose the symmetry which thus far had been integral to his viewpoint.

I had sensed that there were many recuperative qualities to be found in White. Also an optimism (due no doubt to the raging simplicity) centered around good and bad in which good would necessarily triumph.

Dark's melancholy encouraged all the russeting in nature.

White's allegro was entertaining and could be used to "brush away the cobwebs" as Persis Lauder used to say when setting out for one of his lengthy walks.

Incidentally, Miriam, did Persis Lauder ever marry?

I believe someone from The Grange.

Melanie Killigrew?

I even think they had a child. Yes, you're right it was Melanie Killigrew.

Suddenly I was up a country lane. I retreated to the left fork that brought me away from autumn's bowers to the subject at hand. White.

There was a practicality to be admired in White. I should put all these "to be admired's" in a column. Yet that was risky as one side might outnumber the other. Dark's disapproval would cast a heavy shadow. Better for an additional fee to keep them in my head, inasmuch as I had taken all the expenses: incurring insomnia, indecision, impracticality, seasonal affronts, dissipations, tenureship, giddiness, fits, even travel.

Further, although the future of Dark might go up in smoke, White was less likely to disappear in thin air. The adjacencies of

Dark, like the buttresses of Notre Dame (under whose cliff I had once spent a summer while easing Dark into the Bibliothèque Nationale) were more supportive than decorative, no matter how they "flew"; and White might appear as a colon on a Bernini facade so delicate was the curve of its form. Thus Dark's ponderous surface might well do with a few enclaves addressed to White.

I began to cast surprising ayes for the future of White. They lay there on top of Dark's own masquerades, twin treasures, something like Shakespearian vaultings, or hidden Venetian escapades suddenly revealed in an uproar of iambic pentameter . . .

At least you're not going into this in a half-assed manner, Miriam granted.

I'm doing my best. It's much more difficult than you can imagine to cope with two subjects, rather than one. I am looking for complementary routes, and sometimes I have to make them up. I don't have a chart to go by.

I miss Mewshaw. I've missed him all summer.

I miss Mewshaw's Morgan.

I wonder what Eustace is doing.

And Mortashed.

And Mulfinger.

What is Morgan missing? mused Miriam. What with being up half the night hitting the keys in an orthodox manner and only going to the bathroom once and I knew then that he was in there reading. Trying to find a place for White. That's what he is doing in this scheme of things that's like threads posted from chair to door to table, the threads we have been following, almost thriving on in the half light and half life of Morgan and me. The intervals must be catching up, coming closer into one tidy echo. He's waiting to draw a bead on them. This is as near as he has ventured. Sprinkling sand around the door to catch a footprint. There is White, I can hear him say. Who is White? White is Eve, he answers.

There isn't any Eve, Morgan interrupts. Only girls in bathing suits combing their hair dry. Clouds, sand, a skiff, no Eve.

The hot water's been turned off.

There isn't any abstract. Only what's here bunched up.

We're into trouble when something goes off, wanders away, like the hot water.

Why didn't they let you know the hot water would be turned off?

Things stray. People forget. Look for a way out. My trouble is I'm so far inside . . . hampered, lost the intervals.

Miriam had left the sink and returned to the sofa. She lay down, lifting her skirt, fanning herself in the heat. An unnecessary heat, she knew that. If only Morgan would open the terrace door. It was creeping around her. A mugginess into which her will was gradually collapsing. Things surrounded.

When she awakened it was dawn. Fingers of it touching spots on the terrace with light then reaching into the darker corners. Morgan was standing at the open terrace door.

The night had been spongy and wasteful. He kept feeling on shelves for a knife, a pen, a book with which he could sharpen it. His mind left on a sudden ramble taking with it his wits, his cares also. The suddeness of their departure brought a swift coolness into his head; everything cleared, was spatially offset so that both Dark and White appeared as numbers. He had merely to add them. After adding them to take off his shoes. Like a worker returning to his home. He took off his shirt, unloosened his belt. He decided to discard his trousers. There. All was off. Wind, clothes, even "no problem."

There was only that active center with the numbers. It had come to that. Taking the numbers down or apart and laying them straight so that the path might be cleared and then he would see.

The sun was already there, lying on its side, waiting to be turned over. The sum of the two was equal. The numbers were even and he admired them for their manners, their rectitude.

Dark equals White.

What a dunce he had been with all his tomfoolery, his jovian disputes. It had been clear from the beginning.

Yet wait. White had appeared very late in the game. There had been intimations. The quarrels. The disputes. The bad timing. It had not been until he had sensed, vaguely sensed a need for, or a lack of, the Whiteness. Until he had attempted to ease this knowledge into place. Until he had recognized the wholeness of White. It had taken some catching up and a degree of modesty unusual for him. Also a humility to accept Dark's real even urgent need for White. And we must take into account the habits and customs

with which Dark and he had surrounded themselves in their heretofore impenetrable bachelorhood.

Sunrise was streaking the river with thin morning colors. These slender tippings slanting on the water were, he realized, paler hues of the sun setting.

He walked over to her.

How pale you are Miriam, Eve, how white you are. Leaning over her he divided her hair into equal parts.

I think I've found the way.

BARBARA GUEST

Winner of the Lawrence J. Lipton Prize (*Fair Realism*) and the San Francisco State Poetry Award (*Defensive Rapture*), Barbara Guest has come to receive the recognition she deserves. A festschrift celebrating her writing was hosted recently by Brown University. For those acquainted with contemporary poetry, Guest is an outstanding figure.

Born in North Carolina in 1920, Barbara Guest spent her childhood in Florida and California. After graduating from the University of California at Berkeley, she settled in New York City where she connected with the equally emerging New York Poets and artists of Abstract-Expressionism who were then to influence her poetry.

During the 1960s *The Location of Things, Poems,* and *The Blue Stairs* were published. *Moscow Mansions* (1973), *The Countess from Minneapolis* (1976), and in particular her novel *Seeking Air* (1978), pointed to a sense of structure moving in more varied and experimental directions. This was true of her acclaimed biography of the poet H.D., *Herself Defined* (1984), which had consumed five years, and especially of a major poem, *The Türler Losses* (1979), and of *Biography* (1980).

Fair Realism (1989) was followed by *Defensive Rapture* (1993), of which a critic has observed that Guest was now "pushing the reader into the spiritual and metaphysical possibilities of language itself."

SUN & MOON CLASSICS

PIERRE ALFERI [France]
 Natural Gaits 95 (1-55713-231-3, $10.95)
 The Familiar Path of the Fighting Fish [in preparation]

CLAES ANDERSSON [Finland]
 What Became Words 121 (1-55713-231-3, $11.95)

DAVID ANTIN [USA]
 Death in Venice: Three Novellas [in preparation]
 Selected Poems: 1963–1973 10 (1-55713-058-2, $13.95)

ECE AYHAN [Turkey]
 A Blind Cat AND *Orthodoxies* [in preparation]

DJUNA BARNES [USA]
 Ann Portuguise [in preparation]
 The Antiphon [in preparation]
 At the Roots of the Stars: The Short Plays 53 (1-55713-160-0, $12.95)
 Biography of Julie von Bartmann [in preparation]
 The Book of Repulsive Women 59 (1-55713-173-2, $6.95)
 Collected Stories 110 (1-55713-226-7, $24.95 [cloth])
 Interviews 86 (0-940650-37-1, $12.95)
 New York 5 (0-940650-99-1, $12.95)
 Smoke and Other Early Stories 2 (1-55713-014-0, $9.95)

CHARLES BERNSTEIN [USA]
 Content's Dream: Essays 1975–1984 49 (0-940650-56-8, $14.95)
 Dark City 48 (1-55713-162-7, $11.95)
 Republics of Reality: 1975–1995 [in preparation]
 Rough Trades 14 (1-55713-080-9, $10.95)

JENS BJØRNEBOE [Norway]
 The Bird Lovers 43 (1-55713-146-5, $9.95)
 Semmelweis [in preparation]

ANDRÉ DU BOUCHET [France]
 The Indwelling [in preparation]
 Today the Day [in preparation]
 Where Heat Looms 87 (1-55713-238-0, $12.95)

ANDRÉ BRETON [France]
 Arcanum 17 51 (1-55713-170-8, $12.95)
 Earthlight 26 (1-55713-095-7, $12.95)

JACKSON MAC LOW [USA]
Barnesbook 127 (1-55713-235-6, $9.95)
From Pearl Harbor Day to FDR's Birthday 126
 (0-940650-19-3, $10.95)
Pieces O' Six 17 (1-55713-060-4, $11.95)
Two Plays [in preparation]

CLARENCE MAJOR [USA]
Painted Turtle: Woman with Guitar (1-55713-085-X, $11.95)

F. T. MARINETTI [Italy]
Let's Murder the Moonshine: Selected Writings 12
 (1-55713-101-5, $13.95)
The Untameables 28 (1-55713-044-7, $10.95)

HARRY MATHEWS [USA]
Selected Declarations of Dependence (1-55713-234-8, $10.95)

FRIEDRIKE MAYRÖCKER [Austria]
with each clouded peak [in preparation]

DOUGLAS MESSERLI [USA]
After [in preparation]
Ed. *50: A Celebration of Sun & Moon Classics* 50
 (1-55713-132-5, $13.95)
Ed. *From the Other Side of the Century: A New American
 Poetry 1960–1990* 47 (1-55713-131-7, $29.95)
Ed. [with Mac Wellman] *From the Other Side of the
 Century II: A New American Drama 1960–1995* [in preparation]
River to Rivet: A Poetic Trilogy [in preparation]

DAVID MILLER [England]
The Water of Marah [in preparation]

CHRISTOPHER MORLEY [USA]
Thunder on the Left 68 (1-55713-190-2, $12.95)

GÉRARD DE NERVAL [France]
Aurelia [in preparation]

VALÈRE NOVARINA [France]
The Theater of the Ears 85 (1-55713-251-8, $13.95)

CHARLES NORTH [USA]
New and Selected Poems [in preparation]

TOBY OLSON [USA]
Dorit in Lesbos [in preparation]
Utah [in preparation]

MAGGIE O'SULLIVAN [England]
Palace of Reptiles [in preparation]

SERGEI PARADJANOV [Armenia]
Seven Visions [in preparation]

ANTONIO PORTA [Italy]
Metropolis [in preparation]

ANTHONY POWELL [England]
Afternoon Men [in preparation]
Agents and Patients [in preparation]
From a View to a Death [in preparation]
O, How the Wheel Becomes It! 76 (1-55713-221-6, $10.95)
Venusburg [in preparation]
What's Become of Waring [in preparation]

SEXTUS PROPERTIUS [Ancient Rome]
Charm 89 (1-55713-224-0, $11.95)

RAYMOND QUENEAU [France]
Children of Clay [in preparation]

CARL RAKOSI [USA]
Poems 1923–1941 64 (1-55713-185-6, $12.95)

TOM RAWORTH [England]
Eternal Sections 23 (1-55713-129-5, $9.95)

NORBERTO LUIS ROMERO [Spain]
The Arrival of Autumn in Constantinople [in preparation]

AMELIA ROSSELLI [Italy]
War Variations [in preparation]

JEROME ROTHENBERG [USA]
Gematria 45 (1-55713-097-3, $11.95)

SEVERO SARDUY [Cuba]
From Cuba with a Song 52 (1-55713-158-9, $10.95)

ALBERTO SAVINIO [Italy]
Selected Stories [in preparation]

LESLIE SCALAPINO [USA]
Defoe 46 (1-55713-163-5, $14.95)

ARTHUR SCHNITZLER [Austria]
Dream Story 6 (1-55713-081-7, $11.95)
Lieutenant Gustl 37 (1-55713-176-7, $9.95)

CARL VAN VECHTEN [USA]
Parties 31 (1-55713-029-9, $13.95)
Peter Whiffle [in preparation]

TARJEI VESAAS [Norway]
The Great Cycle [in preparation]
The Ice Palace 16 (1-55713-094-9, $11.95)

KEITH WALDROP [USA]
The House Seen from Nowhere [in preparation]
Light While There Is Light: An American History 33
 (1-55713-136-8, $13.95)

WENDY WALKER [USA]
The Sea-Rabbit or, The Artist of Life 57 (1-55713-001-9, $12.95)
The Secret Service 20 (1-55713-084-1, $13.95)
Stories Out of Omarie 58 (1-55713-172-4, $12.95)

BARRETT WATTEN [USA]
Frame (1971–1991) [in preparation]

MAC WELLMAN [USA]
The Land Beyond the Forest: Dracula AND *Swoop* 112
 (1-55713-228-3, $12.95)
The Land of Fog and Whistles: Selected Plays [in preparation]
Two Plays: A Murder of Crows AND *The Hyacinth Macaw* 62
 (1-55713-197-X, $11.95)

JOHN WIENERS [USA]
707 Scott Street 106 (1-55713-252-6, $12.95)

ÉMILE ZOLA [France]
The Belly of Paris 70 (1-55713-066-3, $14.95)

*

Individuals order from:
Sun & Moon Press
6026 Wilshire Boulevard
Los Angeles, California 90036
213-857-1115

Libraries and Bookstores in the United States and Canada
should order from:
Consortium Book Sales & Distribution
1045 Westgate Drive, Suite 90
Saint Paul, Minnesota 55114-1065
800-283-3572
FAX 612-221-0124

Libraries and Bookstores in the United Kingdom and on the Continent
should order from:
Password Books Ltd.
23 New Mount Street
Manchester M4 4DE, ENGLAND
0161 953 4009
INTERNATIONAL +44 61 953-4009
0161 953 4090

NTC